MORTON F. PLANT

and the

CONNECTICUT SHORELINE

Philanthropy in the Gilded Age

GAIL B. MacDONALD

THE
History
PRESS

Published by The History Press
Charleston, SC
www.historypress.net

First published 2017

ISBN 978-1-5402-2550-4

Library of Congress Control Number: 2017938330

Notice: The information in this book is true and complete to the best of our knowledge. It is offered without guarantee on the part of the author or The History Press. The author and The History Press disclaim all liability in connection with the use of this book.

To my grandfather, who first instilled in me a love for learning; my dad, who always will be in my heart and who I wish was still here to see this book; and to Bruce, my life's partner, who has been my rock and has always believed in me, even when I didn't believe in myself.

CONTENTS

Acknowledgements

I was first dazzled by the Branford House in 1980 as a young reporting intern for *The Day* of New London. The stories behind the mansion were a reporter's dream: the son of a railroad tycoon who forged his legacy in the final eighteen years of his life; the flamboyant third wife for whom he traded his Manhattan townhouse to Cartier's for a magnificent string of pearls; and the sad decline of the house in the decades following his son's death. I was smitten by Branford House and won my first journalism prize with the publication of a Sunday feature story about it. That article planted the seeds for this book.

I hesitate to acknowledge by name all those who assisted with this book, lest I forget anyone. This has been a long journey.

During my research, I met and was helped by many archivists and librarians at a range of public and specialty libraries. They helped me not only dig out resources but also unravel some mysteries and inconsistencies. Susan Carter and the other staff at the Henry B. Plant Museum archives in Tampa, Florida, were especially helpful. I extend a special thanks to them.

Closer to home, staffers at the Mystic Seaport, the Dodd Center at the University of Connecticut and Connecticut College were phenomenal, as were those at the Groton Public Library, whose local history archive I returned to again and again. Members of local historical societies in Ledyard; Groton; New London; Branford; Northampton, Massachusetts; and Fort Myers, Florida, were integral in helping with my research and setting the record straight in several instances. Vanessa Cameron at the

New York Yacht Club library graciously showed me the half hulls of Plant's yachts, the magnificent model of his yacht *Iolanda* and numerous books and scrapbooks in the library collection. All helped reveal Plant the sailor.

I also am extremely grateful to James Streeter, Groton's town historian, who is a local Morton Plant expert. He has researched Plant extensively and graciously agreed to meet with me and discuss my book.

I can't overlook the enthusiastic assistance provided by Frederick L. Plummer at the Library of Congress in helping find photographs used here. Others also were integral in helping me secure and adequately reproduce historic photographs, including Stonington, Connecticut photographer Joseph Geraci and Stephen Cersosimo at Granite Photo in Westerly, Rhode Island.

I also very much appreciated the time spent by the personnel at Stone's Ranch Military Reservation in East Lyme. They gave me a thorough tour of this immense property that once was just a portion of the Morton F. Plant State Game Preserve.

I offer my deepest appreciation to a source who asked to remain anonymous but who absolutely made Morton Plant come alive for me. Without her help, this book would not have come together. Thanks also go to my loving and supportive husband, Bruce; my friend and former university colleague Tim Kenny; and fellow journalist and lover of local history Marilyn Comrie. All three read and offered edits and suggestions for this manuscript—thank you, thank you, thank you.

Finally, I must thank former Groton town historian Carol Kimball, who died in 2010. Carol spent countless hours discussing local history with me during my first years as a young reporter for *The Day*. Her help was integral to my reporting on numerous topics, including several related to Plant: the Branford House, Plant's first Eastern Point house, the Shennecossett Golf Club history and the history of Groton–New London Airport. She never was too busy to help ensure that my numerous history-focused articles were accurate and fun to read. I admire Carol's knowledge and patience and am deeply indebted to her.

MORTON F. PLANT,
MAN OF INFLUENCE

A group of men in bowlers and fedoras, pocket watch chains dangling from suit vests, crowded the New London, Connecticut train station platform as the afternoon shadows lengthened. It was November 7, 1918. A breeze from the nearby Thames River fluttered over the tracks, but the day was fair, with blue skies and temperatures in the high forties. The hulking red brick train station obscured much of the main business district, including the twenty-year-old Civil War memorial obelisk, from the group's view. The memorial stood in the middle of the Parade, a cobblestoned gathering spot encircled by brick, limestone and granite buildings housing a collection of clothing stores, millinery shops, groceries, newsstands, hotels, druggists, fishmongers and sweet shops. Typically busy and noisy, with streetcars, horse-drawn wagons and automobiles clattering through the square, on this day businesses stood temporarily shuttered and silent out of respect for the man for whom the contingent of smartly dressed officials waited on the train platform.

The men checked their watches and scanned the tracks approaching the city from the west, searching for the express train from New York City. A special car had been attached to the express just before it steamed out of Manhattan for the three-hour trip east. Mayor E. Frank Morgan and members of the New London Court of Common Council stood waiting alongside Congressman Richard P. Freeman and Judges Arthur B. Calkins and William B. Coit. One group of men represented the city's Thames Club, a bastion of cigar-smoking, bourbon-drinking male wealth and

power. Another group came from the New London Lodge of Elks. Their regalia added a splash of color to the otherwise somber clothing the other men wore.

Less than a half mile away at the top of State Street, the courthouse flag fluttered at half-staff. At 4:15 p.m., minutes after the train hissed to a stop in New London, trolleys all along the Connecticut shoreline halted for five minutes. The trolley line's owner, whose body was carried in the special train car being awaited at the station, had died three days earlier in New York City. Now, he was coming home to the place he loved best.

When the train arrived, the hand-carved rosewood casket bearing the body of Morton Freeman Plant was unloaded just yards from the Thames River docks from which, over the prior fifteen years, thousands of train passengers were ferried to the Griswold Hotel, Plant's luxury resort on the east bank of the Thames. Many others also were shuttled from here via Plant's private boat launch to the rocky promontory where the Thames met Long Island Sound to visit the $3 million granite summer mansion he built in 1903, dubbed Branford House in honor of the Connecticut shoreline town of his birth.

Now, Connecticut was mourning Plant's death. Six members of the Elks Lodge lowered his casket from the train and loaded it onto a hearse. Those gathered at the station began a two-mile journey northwest, away from the river and piers. Through the business district, they passed Davis & Savard shoe store; Kozinos Brothers' candy and ice cream shop; G.G. Avery's hack and livery, which now rented both automobiles and horse-drawn carriages; the Hotel Royal, which advertised rooms costing from $2 a night and featuring hot and cold running water, steam heat and a telephone in every room; and the National Bank of Commerce (capital $300,000), where Plant had served as a director.

The hotel where members of Plant's baseball team stayed while playing in the city and a handsome office building Plant owned were just a short distance up State Street. More than a mile from the station, the landscape greened. Trees lined the gravel streets. At the city's western boundary, the procession entered Cedar Grove Cemetery. A crowded jumble of headstones marked the graves of the city's earliest settlers in one corner, while neat rows of white marble markers stood over Civil War veterans' graves in another area. A short distance from these graves rose grassy hillocks, deeply shaded by cedars, oaks and maples. The land sloped down to a willow-bordered pond near Cedar Grove Avenue.

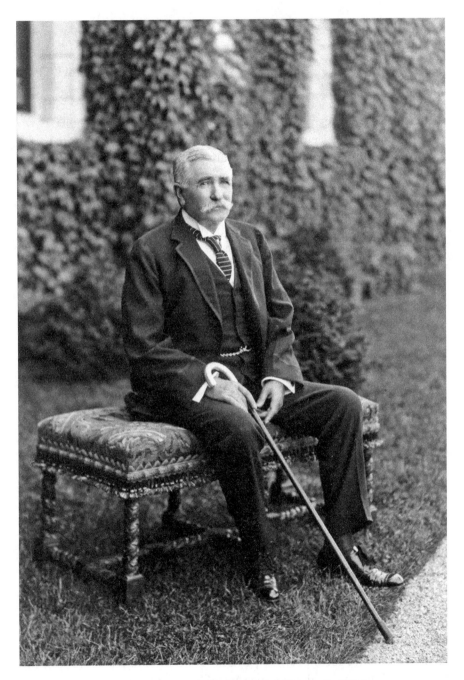

Morton Freeman Plant in contemporary business attire. *Plant Family Collection.*

In these more spacious plots, the most influential of the city's more recent residents were buried—whaling captains, physicians, politicians, lawyers and bankers. Plant joined these notables. A substantial oval granite marker simply adorned with raised letters spelling out "Morton F. Plant" and topped with a chiseled laurel garland marked his grave near the center of the cemetery. On his burial day, the procession from the train station joined another group of mourners at the cemetery. Women stood in wide-brimmed hats, fur wraps around their shoulders. They were joined by men in stiff, dark suits. As the sun set, they formed a group of more than two hundred crowded around the flower-banked grave, reciting the Lord's Prayer as the casket was lowered into a mahogany box. Plant's second wife, Nellie Capron, who died of typhoid at age forty-nine, had been buried here five years earlier. Plant's only biological son, Henry, would join his parents here when he died two decades later at age forty-three in 1938.

There were plenty of momentous events for the *New London Evening Day* to report at the time of Morton Plant's death, including news from the World War I battlefields of France just four days before the Armistice, stories about recent elections that left New London in Democratic hands and President Woodrow Wilson contending with a Republican-controlled Congress and reports of the most recent victims of both the war and the Spanish flu epidemic that was reported to have first shown up in New London via sailors stationed in the community. Yet Plant's death and burial earned prominent news coverage befitting a man who greatly reshaped the community in the two decades before his death.

The paper also overflowed with advertisements for all types of supposed cures for the Spanish flu. Among these was Borden's malted milk. But neither homegrown cures nor contemporary medicine could stave off the global flu pandemic. Plant—who survived storms at sea, accidents and typhoid fever—was one flu victim among some 50 million worldwide. In an obituary published on November 5, *The Day* reported Plant was ill a week before his death, having caught what was thought to be a severe cold when traveling the distance of about 7.4 miles from his office at 61 Broadway in New York City to his home at 1051 Fifth Avenue. His son Ensign Henry B. Plant, along with Morton's third wife and adoptive son, Philip M. Plant, were at his Manhattan bedside at the time of Morton's death. Three days later, Philip and Morton's widow, Maisie, were themselves too ill with the flu to travel to the burial in southeastern Connecticut.

On the same evening *The Day* reported Plant's death at age sixty-six, the paper editorialized about the man, calling his death a disaster for the region.

"It is a disaster because he was not only one of our best hearted citizens, but one of the most useful," *The Day*'s editor wrote. "It is difficult to say how our people might have managed without his means and interest."

After reminding readers of some of the ways Plant supported the region, the editor wrote, "The breadth and substantialness of his kindness in these ways goes far beyond the public knowledge....What a patience he had with the hundreds upon hundreds who were constantly running to him with one and another errand of importunity. Courteous always, receptive, fair minded, considerate. A more democratic and genuinely neighborly man we did not know."

Plant earned the region's accolades in the final third of his life. Until he was in his forties, he lived in the shadow of his father, Henry B. Plant, a brilliant business tycoon who made shrewd business decisions and investments in the South in the pre– and post–Civil War years and developed a system of railroads instrumental in opening Florida to economic development. Morton began working for one of his father's companies, the Southern Express Company of Memphis, at age sixteen and began making a mark in the transportation industry, as well as as a hotelier, yachtsman and financier. Before his father died in 1899, however, Morton got much less notice publicly than the elder Plant.

Morton Plant's astonishing and eclectic array of interests and the causes he helped bankroll, however, would soon change his public persona. Transportation innovations seemed to prove irresistible to him, and he invested, quite heavily in some cases, in everything from improving roads for automobiles to the Wright brothers' aviation company to the New York City subway system to construction of the Cape Cod Canal. Yet he also displayed some nostalgia for simpler times with his interest in preserving and promoting agriculture, ensuring that his community had a proper town hall and even paying to paint a humble country church.

After Henry B. Plant's death, Morton and Henry's widow, Margaret, almost immediately came to the public's attention with their audacious challenge of Henry's most unusual will. Perhaps believing the widow and son would fritter away the fortune he built, Henry's will stipulated that Morton and Margaret would have access only to some $30,000 annually, an amount that would allow them a comfortable but not grandiose lifestyle. The will further stipulated that the entire estate would be held in trust for his four-year-old namesake grandson and that the trust couldn't be dissolved until that grandson's youngest child turned twenty-one, wrote Kelly Reynolds in the book *Henry Plant: Pioneer Empire Builder*. Morton and his stepmother

eventually won their court challenge, and Morton walked away with a reported $14 million to $17 million. The variation in amounts depends on what publication reported the news.

Once Morton succeeded in his legal challenge, he appeared to take seriously the millionaire industrialists' credo of the day—people such as he had the responsibility to go beyond their lavish personal lifestyles to also support their communities. He never demonstrated his father's business acumen, however, and in fact lost a fortune on his trolley company and enterprises that included so-called model farms, where Morton employed the most current and expensive agricultural practices. His influence in Connecticut, especially in the southeastern part of the state, however, extended well beyond his lifespan.

Andrew Carnegie, the rags-to-riches steel tycoon who died in 1919, a year after Morton Plant, in 1889 wrote about the philanthropist philosophy to which he adhered. Not only did Carnegie and his fellow industrialists accept the great disparity between America's wealthy few and its vast numbers of poor, but they also believed this was natural, a sort of appropriate and preordained social order.

"We accept and welcome...a great inequality of environment; the concentration of business, industrial and commercial, in the hands of the few, and the law of competition between these, as being not only beneficial, but essential to the future progress of the race," Carnegie wrote in the *Gospel of Wealth*, indicating that those who amassed great fortunes did so because of special talents and innate characteristics. But with these talents and the material wealth they brought came a responsibility to ensure that at least some of that wealth was used for the betterment of mankind, he contended.

"There are but three modes in which surplus wealth can be disposed of," Carnegie wrote. "It can be left to the families of the decedents; or it can be bequeathed for public purposes; or, finally, it can be administered by its possessors during their lives." He called the first option injudicious. The second option could result in the money not being used as intended and public questioning of motives. Instead, he called on his peers to choose the third option for their money:

> *Under its sway we shall have an ideal state, in which the surplus wealth of the few will become, in the best sense, the property of the many. This wealth, passing through the hands of the few, can be made a much more potent force for the elevation of our race than if distributed in small sums to the people themselves....This then, is held to be the duty of the man*

of wealth: To set an example of modest, unostentatious living, shunning display or extravagance; to provide moderately for the legitimate wants of those dependent upon him; and after doing so, to consider all surplus revenues which come to him simply as trust funds, which he is called upon to administer, and strictly bound, as a matter of duty to administer in the manner which, in his judgment, is best calculated to produce the most beneficial results for the community—the man of wealth thus becoming the mere trustee and agent for his poorer brethren, bringing to their service his superior wisdom, experience and ability to administer, doing for them better than they would or could do for themselves.

While few of the wealthiest nineteenth- and early twentieth-century industrialists lived modestly and unostentatiously, many of them, including Plant, did work to ensure that at least a share of their fortunes were committed to the public good. More than a century beyond their deaths, the public continues to benefit from the schools, libraries, parks and hospitals these men established. Morton Plant's money enhanced many communities. In 1914, he donated $100,000 to build the hospital that still bears his name in Clearwater, Florida, for example. His son was seriously injured in a 1912 accident in which he was thrown from an automobile. Finding insufficient medical care in the region at that time, Morton Plant had a railroad car converted with hospital equipment and sent from Chicago. In addition, he paid a doctor and nurses to care for Henry full time for three months and then worked to ensure the establishment of a local hospital that would eliminate the need for such lavish expense in the future.

The region that reaped the most from Plant's altruism was southeastern Connecticut, where he chose to live during the summer months, attracted to its coastline and expanses of undeveloped land. Among other donations in the region, he gave more than $1 million to help establish Connecticut College for women in New London and provided generous donations to the city's hospital and the town of Groton, the location of his summer home. Just as significant, his lifestyle supported and shaped the community in integral ways, especially in Groton, where at the time the vast majority of residents lived simple, basic lives. Almost as the Catholic Church for years provided the only means through which masters of the fine arts could flourish, Plant's activities, businesses and hobbies provided a financial lifeline for many people in the region who otherwise might not have thrived.

Plant employed hundreds in Groton, including highly skilled workers such as master chefs, gardeners and craftspeople at the Griswold Hotel, as well

as fifty workers year-round at his mansion the Branford House. He gave Groton's municipal government money to build a new town hall and gave tens of thousands of dollars to improve roads in the region at a time when stone-strewn dirt paths were the norm. His support also kept agricultural scientists and botanists busy at his three-hundred-acre Branford Farms. Plant donated land on which Groton's first Catholic church was constructed, providing a spiritual haven for the Italian artisans he brought to this country to help build Branford House. He ran a minor-league baseball team that built community spirit and provided entertainment for many. Plant treated the ballplayers fairly, and they repaid him with their loyalty and two pennants.

Plant's interest in fishing and hunting led him to preserve thousands of acres of East Lyme land that would later become public. He employed seventy people to build a macadam road to that town's game preserve. He also operated an interurban trolley line that provided mass transport at reasonable rates to schools, offices, commerce and factories. He donated a house he owned in Groton for use as a military hospital during World War I and 350 acres for use as a summer camp for engineering students at Sheffield Scientific School at Yale University. Plant was among the wealthy yachtsmen of his time who frequently hired Rhode Island's Herreshoff shipyard to design and build his racing yachts and bought a bevy of extremely expensive automobiles requiring mechanics and chauffeurs at a time when very few in rural Connecticut owned cars.

In his will, Plant left another $250,000 to Connecticut College, $100,000 to Lawrence Hospital in New London and more than $200,000 to a variety of people he employed. His will also authorized trustees to operate Branford Farms "so long as they may deem it beneficial to the agricultural development of the county to do so, although such operation may not be profitable." The land eventually was deeded to the state, and part of it is now the site of Groton–New London Airport.

In the years before Morton Plant's death, the *Hartford Courant* repeatedly called him the state's wealthiest resident. On the last day of 1911, in a report in the *Idaho Statesman* about Americans who had given $1 million or more for philanthropic reasons, Plant was listed among eight who gave at the $1 million level, about $24.3 million in 2016 dollars. Eight others gave more than $1 million, including Andrew Carnegie, whose donations to education and research totaled some $40 million that year, some $972.4 million in current dollars.

While Plant's relatively lower amount of wealth did not allow him to play in quite the same league as did Carnegie, Plant ensured that he would play

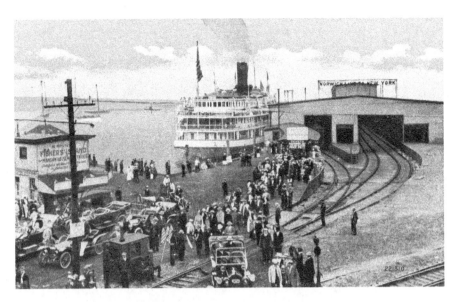

New London's train station and nearby steamboat dock bustled in the early 1900s. The ferry regularly sailed across the Thames River between New London and Groton. *Groton Public Library Local History Collection.*

a more integral role in shaping lifestyles of southeastern Connecticut. "He gave generously to all public institutions and enterprises and to countless private charities," *The Day* noted in Plant's obituary.

Plant's death was deeply mourned. Despite fears over the spread of the flu, a crowd attended his funeral "just as the sun was sinking to rest," *The Day* reported. Near a cluster of cedar trees and a hefty granite marker for a West Point graduate named Augustus Cleveland Tyler, who had died ten years earlier, the mourners recited the Lord's Prayer as Plant's body was lowered into the grave. Even after the service, many lingered in the leafy silence of the cemetery.

"It was one of the most impressive funerals ever in New London," *The Day* reported. "And a marked tribute of respect to a citizen who was widely loved.

THE TIMES THAT SHAPED PLANT

The goings-on at the sprawling and stately granite mansion at the tip of Avery Point, just south of the Eastern Point summer colony in Groton, were a constant source of intrigue and diversion for local residents as the world teetered closer to World War I, which would also be called the "Great War" or the "War to End All Wars." After laboring some fifty-five hours a week to earn about eleven dollars, working-class residents of southeastern Connecticut in 1914 were willing to spend a nickel or a dime to be swept into the silent screen romances and adventures of Mary Pickford and Douglas Fairbanks at the local movie theater. But a person who seemed a far more real star lived in their midst, just behind the tall granite walls and wrought-iron gates. Local residents were enthralled by the white-haired, mustachioed gentleman who sailed to so many exotic ports. He frequently was portrayed in the contemporary press as charming, if enigmatic. His longtime wife, Nellie, was an elegant and more private person, not subject to the kind of gossipy speculation that later swirled around Morton's third wife, Maisie, who was half his age and flamboyant.

In fact, the Plants provided much fodder for local gossip. Were those pearls Maisie wore *the* pearls, the ones for which Morton traded his Manhattan townhouse to Cartier's? What about that *New York Times* headline that read "Capitalist Weds Divorcee at Branford House, His Summer Home in Groton"? Did he really give her $8 million as a wedding gift? Or was it, as some said, an $8 million gift to her ex-husband and local hotelier, Seldon Manwaring, in return for his agreement to grant her a divorce? Then

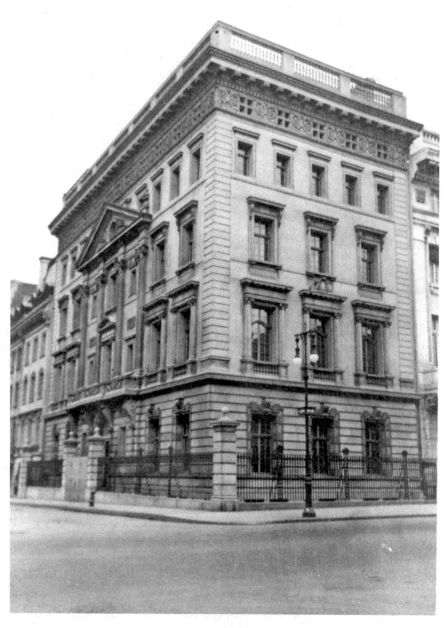

Morton Plant's New York City townhouse. The Fifth Avenue building has been home to Cartier since Plant traded it for a string of pearls for his third wife, Maisie. *Plant Family Collection.*

there was Maisie's son, whose frequent drunken exploits with starlets and showgirls filled gossip columns but whom Morton nevertheless adopted, at Maisie's insistence.

On September 27, 1914, a lengthy article in the *Hartford Courant* described Branford House, which had been completed a decade earlier and designed by his wife, Nellie Capron Plant. The writer for the statewide paper reported that the estate was "seen only by those with social entrée."

"To one who has not the password which admits a swift trip across New London Harbor to the long, low dock and cosey [*sic*] boathouse perched on a rock at the extreme end of the demesne, or through the trim gates at the end of a long ribbon of perfect road, guarded by a neat little lodge, the place is terra incognita," the writer reported, referring to a typical arrival at Branford House via the private launch that Plant kept on the Thames River near the New London railroad station.

Plant and others of his social class walked a public-private tightrope. Plant guarded his privacy, often shunned photographers and kept a tight rein on his emotions in public, even if he was said to use salty language in private. A newspaper report that Plant lost his temper over receiving a speeding ticket in southwestern Connecticut was a rare report of Morton Plant's emotions. Despite his steady, somewhat unexciting persona, in the final two decades of his life, when he made most of his public donations, journalists wrote about him extensively and he regularly was asked to become part of community causes large and small.

On one hand, the Plants appeared to delight in allowing the public at least a few peeks into their private lives. But it was controlled access they offered, carried out on their own terms. They made every attempt to shield themselves from the mean, dirty streets so common at the turn of the twentieth century, as well as the public who lived and worked in the more typical neighborhoods of the day. Besides situating his Branford House atop a rocky peninsula and encircling its landward side with walls, gates and human gatekeepers, Plant even took pains to block the malodorous air so typical at a time when horses and livestock were plentiful and garbage disposed of in open heaps in most yards. Plant couldn't stop the odors at his property line, but he did the next best thing. He bought nearby Pine Island, a small, rock-strewn clump of land just east of Branford House, for only one purpose—to clear it of the Quinnipiac Fertilizer Company operations. The company used rotten fish in its fertilizer, and Plant and his family were offended by the smell. The Plants transformed the island into a sheep pasture and wooded playground.

Plant and other wealthy families of the time frequently welcomed news reporters and photographers into their homes and lives. News of their parties, teas, exotic travel, dances, charity events, tennis matches and yacht races filled the news.

Plant's own global travels, seafaring gambols and yachting exploits frequently were mentioned in society columns. If he and Nellie attended a wedding in Bar Harbor, Maine; a party in Newport, Rhode Island; or entertained royal guests on their yacht while traversing through Europe, a newspaper reporter someplace dutifully recorded it. It wasn't until June 1899, however, at a time when Plant was reported to be immersed in summer relaxation aboard a yacht someplace near New London when his father died, that Morton's life assumed a more serious-minded tone. He was forty-

Nellie Capron Plant, Morton's second wife. She was not overly fond of sailing but did spend time on the water with her husband. *Plant Family Collection.*

six years old when Henry Bradley Plant, the person who elevated the Plant family from one of long-standing comfort and respectability to the heights of the fabulously wealthy, died at home on Fifth Avenue in Manhattan. Henry Plant's *New York Times* obituary described him as a man of "charming simplicity of manner, fair of mind, kind of heart," an adventurous, restless spirit.

Henry Plant was born in Branford, Connecticut, where his son Morton also would be born. The Plants were of distinguished lineage. Among their ancestors were members of the European founding families of both Branford and Hartford, Connecticut's capital city. These included soldiers of King Philip's War and the American Revolution. Henry began working for the New Haven Steamship Company when he was still a boy. When he was a young man, Henry was appointed the superintendent of a company providing regular transportation of the mail, mercantile goods and passengers—the southern division of the Adams Express Company.

He began spending considerable amounts of time in Augusta, Georgia, and traveling extensively throughout the South on company business.

The timing, combined with particularly shrewd decisions Henry Plant made, paid off lavishly. Not only did Plant become entrenched in the burgeoning railroad business in its infancy, but in 1861, he also gained control of the southern lines of the Adams Company because of his familiarity with the South. The timing could not have been more fortuitous. The Confederacy had just been formed, and Northern businesses operating in the South were likely to be confiscated. Henry moved south largely for his wife's health, but for an ambitious young man, he was in the right place at the right time, and he seized the moment.

Henry stayed on in the South throughout the early Civil War years. At the height of the war, he left the South but returned to this familiar ground after the war, when the territory was in ruins. He rebuilt and expanded the tattered infrastructure, becoming extremely wealthy in the process. Henry Plant also recognized opportunity in Florida—an area still largely a swampy, exotic frontier at the time. He first saw Florida from a dugout canoe when, in the years prior to the Civil War, he searched for a home in a warmer climate to try to aid his ailing wife, Ellen Elizabeth Blackstone. Despite his efforts to find a more hospitable climate for her, she died at age forty-seven, a victim of tuberculosis. Morton, their only child, was eight years old.

Because of his father's business pursuits and his mother's illness and death, Morton spent much of his childhood with his grandparents in New Haven and Branford, Connecticut. Father and son were almost strangers to each other. By the 1880s, Henry Plant was building and expanding railroads through the South, predominantly in Florida. He extended a line to Tampa, making the Florida Gulf Coast community the port of entry for mail service to Havana, Cuba, and north to Savannah, Georgia. He cemented the success of his southern railroads by developing eight resort hotels at train stops, including the lavish Tampa Bay Hotel, now owned by the University of Tampa and used as offices, classrooms and a museum dedicated to Henry Plant. For a short time, the Tampa Bay Hotel was a focal point of high society—hosting government officials, writers, musicians, actors and athletes. Among the recreational pursuits offered to guests were guided hunts, horse racing, golf and boating. Teddy Roosevelt and his Rough Riders stayed on the hotel's vast grounds before shipping out to Cuba during the Spanish-American War.

Morton spent time at the Tampa Bay Hotel and held some business responsibilities there. He also oversaw another nearby lavish Plant hotel,

the Belleview in Clearwater, Florida. But Morton also was publicly embarrassed on the Tampa Bay's veranda when, during a sixty-seventh birthday celebration for Henry, the elder Plant gazed at his infant grandson in Morton's presence and proclaimed the future of the Plant fortune lay with the tiny child, according to Kelly Reynolds in his book *Henry Plant: Pioneer Empire Builder.*

When Morton's legal battle to overturn his father's will succeeded in 1904, the son came into his own as businessman, investor and influence on his community. Much of that influence he chose to exert in southeastern Connecticut. Reports of how much of his father's money Morton inherited vary, but some reports put it at $15 million, an amount that would be between $218 million and $409 million in 2016 dollars. This was substantial, yes, but not when measured against fortunes amassed by business titans to come. To cite but one, Bill Gates's net worth was set at $81.7 billion on the Forbes 2016 list of the wealthiest Americans.

When compared to the average lifestyle in 1900, however, Plant's inheritance takes on a new perspective. Southeastern Connecticut was a region of working men and women, many of whom were unskilled mill or farm laborers. Factories, most producing textiles ranging from woolens to velvet, teemed on the region's waterways, much as they had since the early days of the Industrial Revolution. The shoreline continued to be dominated by shipyards, which were common for decades before the turn of the twentieth century. New London was a center of the whaling industry, a business already in steep decline by 1900. Not far from where Morton Plant spent $3 million to build Branford House in 1903, a shipyard began turning out steel-hulled ships. Eastern Shipbuilding occupied a former railroad ferry yard and in 1903 and 1904 completed work on what were then the world's two largest steel freighters. The Borough of Groton, which includes the Eastern Point summer colony where Plant built both his mansion and resort hotel, incorporated in 1903 and began operating a waterworks and electrical utility, primarily to keep the shipyard in business. The first railroad bridge over the Thames was built in 1889, and in 1904, the sprawling Midway Railroad Yard, so named because of its location between Boston and New York, was completed. Midway was located on land not far from Plant's farm.

Away from the southeastern Connecticut shoreline and its shipbuilding and fishing villages, acres of farms and vast swaths of undeveloped land stretched east and north. Here Plant could indulge his passion for yachting while also developing land as he wanted. His fortune, not quite in the league of the Astors, Rockefellers and Carnegies, could have decidedly

more influence in southeastern Connecticut than it might have in Newport, Rhode Island, or Bar Harbor, Maine, which were summer playgrounds for some of the country's wealthiest families. Plant could command a position at the top of the social ladder in the New London area.

The Day newspaper of that time focused primarily on news of interest to the burgeoning middle class. While the front page carried stories that held potentially serious implications for all Americans—the progress of the Boer War, the national political conventions and Teddy Roosevelt's speeches—inside pages were full of chatty gossip, listings of church suppers and picnics and the public library's newest book purchases. In May 1904, the "Groton Topics" column included news of residents entertaining out-of-town visitors, Sunday school attendance, a local fruit dealer's injured horse and a resident fined for illegally selling liquor. The news columns also featured frequent complaints about boys playing ball in the streets and unregistered, roaming dogs.

While the community's huge number of poor people and immigrants were largely invisible to newspapers of the time, what is evident is that life for all was relatively dangerous and brutal. Nationally, the average worker in 1900 earned less than thirteen dollars for a fifty-nine-hour workweek. It was not unusual to see children younger than ten at work in dangerous, dirty factories, where government safety measures were only beginning to be imposed. Children also worked on the docks and in stores and hawked newspapers and magazines at all hours of the day and night, as well as for savagely long hours wielding dangerous, heavy farm equipment. Even in areas where restrictions on child labor were adopted, laws often were ignored or excluded immigrants. Fires were common and fire prevention and advances in fire safety techniques of great interest to the public. Sanitation was crude at best, outhouses everywhere and open garbage heaps common. Livestock was often kept, even in small, urban backyards, and horses remained a prime means of transport. In 1900, there were a total of eight thousand automobiles and just ten miles of paved roads nationwide.

The poor, including workers who were severely injured while on the job and no longer able to toil, had few options for financial support. Poor farms and almshouses were operated by municipalities for the most destitute, but there was no large-scale government welfare, no social security for the elderly and no worker's compensation payments. A main danger to all was illness—epidemics of often fatal diseases such as smallpox, diphtheria, measles, scarlet fever and polio. Newspapers were filled with ads for all manner of remedies, most of which were worthless and some downright dangerous.

U.S. life expectancy in 1900 was about forty-seven years for females, forty-six for males and just thirty-three for blacks. There were 115 lynchings reported in the country in 1900. In 1914, *The Day* ran a story about a black man in Salisbury, Maryland, being burned to death as a joke by a group of whites.

Even with all this, the lifestyle for many Americans was decidedly improved by 1900, better than it had been even a few decades earlier. The middle class was growing. The workweek was reduced. Disposable income had grown. Amusements such as vaudeville theaters, silent movie houses, traveling circuses and excursions to parks such as Coney Island, New York, were more commonplace. Trolleys like Plant's Shoreline Electric Railway opened up even more possibilities. They brought crowds to picnic spots and beaches. Summer colonies were more commonplace for those who worked in middle management and white-collar jobs. There were several such colonies in southeastern Connecticut—Pequot Colony in New London and Groton Long Point and Eastern Point in Groton among them. Eastern Point began to develop even before the Civil War, near a small hotel on the Thames River. In 1904, a six-room cottage was selling in New London for $800, and building lots in New London were selling for between $200 and $500. An eight-room cottage near New London's Ocean Beach, complete with "modern plumbing and electric lights," was renting for $300 for the entire summer season. A very fine, two-story, twelve-room house with "furnace heat" on Huntington Street in New London was for sale for $4,500.

Across the Thames River, about four miles away, by 1904 sat Plant's resplendent Branford House and its sprawling, manicured gardens. Besides the money he spent to build the palatial summer digs, he also paid a staff of fifty to work there year-round, with more help during warmer months. To make the neighborhood more upscale, he purchased a shabby riverfront hotel at Eastern Point and, after it closed for the season on Labor Day 1905, had it demolished and rebuilt as a larger and more lavish resort called the Griswold. He expanded and redesigned the hotel golf course based on his experience at the Belleview in Florida, employed an on-site physician and marketed the place to the growing number of upper middle-class Americans who were driving automobiles. He even promoted seaplanes taking off from and landing on the Thames near the resort. He hired hundreds of workers to rebuild the hotel and spent tens of thousands of dollars to improve roads and provide water launches to ensure that his visitors arrived in style. He built a garage on site for their automobiles and hired the top chefs and musicians to provide the best food and entertainment. Plant also oversaw the building of trolley lines to the Rhode Island border about fifteen miles away. Clearly

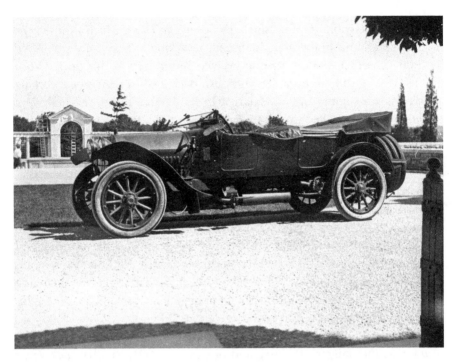

A Simplex automobile at Branford House, Groton. Plant was an early automobile enthusiast and owned several luxury models. *Plant Family Collection.*

this was a case of enlightened self-interest. Relatively well-cared-for workers and a decent transportation system served both his and the community's best interests.

Despite all the trappings of splendor, it was impossible for Plant and others of his social status to shut out the world around them. Factory smokestacks spewed foul air, and rivers in Connecticut often changed colors each time the textile factories used a different dye color. Foul smells were everywhere, and even though Plant eliminated the most odiferous offender nearest his home, he could not entirely block out the odors of garbage dumps, animal excrement and even unclean bodies at a time when deodorant did not exist. Most people owned few changes of clothing, and once-a-week bathing was typical. He could not miss seeing the packs of rough boys clothed in rags sleeping, fighting, gambling and smoking on the city streets when they were not trying to earn a few pennies selling newspapers, including the ones he owned for a time in both New London and Boston.

Plant also was aware of, but did not support, the progressive movement sweeping the United States, threatening the extravagant lifestyles built by

the industrial tycoons. Upton Sinclair's novel *The Jungle*, which exposed the hideous conditions in the unregulated meatpacking industry, was published in 1900. The first modest income tax was introduced at this time. Labor unions were starting to organize and push back against dangerous working conditions, long hours and low salaries. In 1914, labor unrest reached Plant directly when his trolley workers narrowly averted a strike. They agreed to salaries of 22.5 cents an hour for those with five years or less time on the job and 28.5 cents an hour for those with five years or more. Laws regulating child labor were beginning to be instituted, and the long fight for women's suffrage continued. While Bruce Fraser of the Connecticut Humanities Council wrote that most of the progressive movements were ignored in Connecticut, residents could not overlook the tens of thousands of Italian, Polish, Hungarian and other immigrants crowding into the state's cities. The immigrants would help forever change the fabric of the state. There is not much evidence to show what Plant's feelings were about the changing times, beyond his support for the Democratic Party. While he respected his employees, his salaries weren't overly generous.

The most serious threat to all residents, regardless of financial or social strata, was the danger of injury and disease. In 1901, the *New York Times* reported that Plant was ill with typhoid and had fitted a railroad car as an ambulance to take him to southeastern Connecticut. The disease nearly claimed his life. Twelve years later, his wife, Nellie, died of typhoid. In 1907, Plant again was nearly killed in Manhattan when his cab collided with a Lexington Avenue car and he was thrown into the street by the impact. In another instance, Plant underwent a skin graft for a leg injury, a dangerous proposition at the time. By the age of fifty, Plant was walking with the aid of a cane. When the Spanish flu pandemic hit in 1918 and 1919, Plant's family was struck, and Morton Plant died. Both Maisie and her son also fell ill but later recovered. His wealth and celebrity were useless in fighting the disease when widespread vaccines and effective medicines did not exist.

THE YACHTING LIFE

Morton Plant was at home on the sea and had been from an early age. He grew up largely along Long Island Sound in Connecticut and owned his first catboat, a small sailboat, at age thirteen. He spent long stretches of time on the water, cruising to foreign and domestic ports with other members of the Gilded Age elite and frequently making the news, both because of the company he kept and because of the competitive prowess of his racing vessels. Many of his significant life experiences also were at sea. At age twenty-one, Plant joined his father and stepmother on their lengthy honeymoon cruise. He also was at sea when his father died. He commissioned the yacht *Elena* by asking Nathanael Herreshoff simply to build him a schooner that could win. He got his wish, but in 1913, he was at the side of his wife, Nellie, when she died on the same day *Elena* won the Astor Cup. Plant retired *Elena* after his wife's death, selling the vessel to Cornelius Vanderbilt.

Plant made his most exotic voyage aboard his enormous steam yacht *Iolanda*. On October 15, 1909, he was aboard *Iolanda*, just six days after setting out from New London on what would be an almost nine-month trip. It was far from a pleasant start to the journey. The wind blew between forty and fifty miles per hour, and the waves were thirty feet. Indeed, the marine forecast had forced a delay in the planned departure of a local whaler, the *Norwich Bulletin* reported at the time. Plant, however, had little patience for waiting out the weather and started his journey despite the forecast.

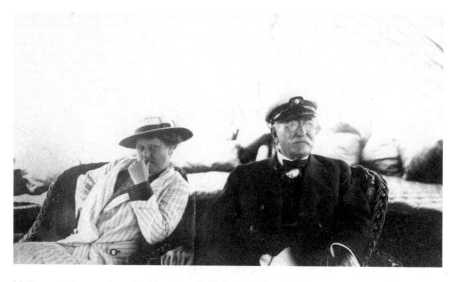

Nellie and Morton aboard a friend's yacht. Morton frequently was called "Commodore" and from an early age was at home on the sea. *Plant Family Collection.*

While Plant owned and commissioned many yachts of a variety of types and sizes, the *Iolanda* was in a class of its own, both because of its size and ostentatiousness. The *Iolanda* was as long as a football field, the third-largest steam yacht in the world at the time and the second-largest privately owned steam yacht. Built in 1908 in Leith, Scotland, by Ramage and Ferguson, *Iolanda* was said to cost $1 million to build, which would be more than $24 million in 2016. It had three decks and was powered by two huge steam engines. It could carry four hundred tons of coal to fire those engines, and Plant celebrated the ship's launch by hosting a luncheon in one of its immense smokestacks. Usually rather shy and private, Plant seemed to revel in the publicity *Iolanda* generated. A February 7, 1908 *New York Herald* article about the vessel featured a photograph of a six-cylinder automobile passing through one of the yacht's fifty-five-foot-long smoke pipes. The article noted that an estimated 520 people could shelter in the yacht. An article in *Field and Stream* noted that it took the *Iolanda* just ten days to cross the Atlantic to its new home in Connecticut.

On Plant's nine-month voyage, *Iolanda* was carrying a small group of his friends and a crew of more than seventy on what would be a thirty-three-thousand-mile journey to exotic ports in Europe, the Middle East and Asia—places few Americans at the time would dare to even dream of seeing. "During the past eighteen hours, as the yacht was rolling so hard,

I did not think it would be prudent for me to move about and risk the severe strain on my leg, so I remained in bed," Plant wrote in a journal that would be published in 1911 as a book titled *The Cruise of the Iolanda.* The leg strain likely referenced a severe leg injury for which he had skin graft surgery in 1903 when he was fifty-one years old, according to an article in the *Philadelphia Inquirer.*

"Thus far, no one has been ill," Plant wrote. Five days later: "I can safely say this has been the roughest passage that I have ever made, but the Iolanda behaved splendidly."

On October 20, the yacht arrived at its first port—the Royal Pier in Southampton, England. Plant and his guests headed to London for sumptuous dining, shopping and sightseeing. For the crew, there was little rest after the difficult Atlantic crossing. For them, life aboard ship meant long days and arduous labor. A small, black leather-bound volume titled *Particulars of Steam Yacht Iolanda 1908* details the exacting rules and work hours of the crew members, who ranged from chefs and maids to deckhands and officers. When the boat was in commission, workdays began at 5:00 a.m. and could extend twelve or more hours. There was no smoking, shouting or needless noise among the staff, and the crew was warned to stay out of any spaces where the guests or owners might be found.

Despite the strict rules, however, working aboard Plant's yacht was both relatively lucrative and no doubt exciting. The crew—about half of whom could go ashore when the yacht was in port—would see the Pyramids in Egypt and exotic cities like Hong Kong, Bombay, Bangkok, Kyoto, Singapore and Venice. On board they might serve world leaders such as Germany's kaiser, Russia's czar and Greece's King George. And at a time when the average U.S. worker earned between $200 and $400 annually, even some of the lowliest jobs on board *Iolanda* paid at the high end of that range, while more skilled positions on the yacht paid ten times or more than the annual U.S. average salary, according to a pay ledger from the yacht. The *Iolanda* alone was estimated to cost Plant $1,000 a day to operate.

While Plant began to make a name for himself as a philanthropist later in life, he first was best known as a yachtsman. He was a member of the prestigious New York Yacht Club, along with the Vanderbilts, Astors and J.P. Morgan, and headed the club's New London station. He also was commodore of New York's Larchmont Yacht Club and a member of the Indian Harbor, St. Georges and Seawanhaka-Corinthian clubs. He frequently was referred to as "Commodore" and took an active role aboard his vessels, unlike earlier generations of yachtsmen, who viewed sail racing in much the same way

as Thoroughbred horse racing. Whether it was horses or yachts, the earlier owners were wealthy amateurs who hired professionals to race.

In July 1914, the *New York Sun* published a full-page illustration featuring an artist's caricatures of eight "Yachtsmen of the World," along with short poems characterizing their personalities. Plant was illustrated standing in front of tall bookcases holding sailing prizes and a ship's model. His poem read, "Morton F. Plant through the spume and the spray; Of the sea like a rocket goes winging; Anchor a-trip, his ship sweeps from the bay; And away she goes outwardly swinging. Colors he flies, mainly red and the blue; Floating blithely regardless of weather; Betoken his heart, like his ship staunch and true; When her spirit is light as a feather."

Plant owned many vessels. A historical feature about Plant in *The Day* of New London in 1965 listed his other yachts as the *Ingomar, Parthenia, Venetia, Shimna, Kanawaha, Thelma, Elena* and *Vanadis*. He also owned boats named for both his second and third wives—the *Nellie* and the *Maisie*.

Ingomar, a 127-foot schooner, won twenty-one prizes in twenty-five races, many at Kiel, Germany. England's King Edward visited the yacht in 1904 at Cowes, and according to a May 7, 1905 *New York Times* article, *Ingomar's* success in overseas yacht races was second only to the schooner *America*.

One story illustrating Plant's uncompromising character aboard ship is told in Robert K. Massie's book *Dreadnought: Britain, Germany and the Coming of the Great War.* As Massie noted, at Kiel Week in 1904, Plant was aboard his yacht *Ingomar*, which was competing against *Meteor III*, the German royal yacht. At one point, *Ingomar* was striving to overtake *Meteor III*, and because *Ingomar* was on a starboard tack, sailing rules called for the German vessel to give way. But *Meteor III*, on which the kaiser was sailing, refused to budge from its course.

As the yachts continued on a collision course, *Ingomar's* crew stood silently, panicky lest they be responsible for sending Germany's ruler to the bottom of the sea. Plant stood on the stairway in the companionway, with his head just above the hatch, a cigar in his mouth and a Panama hat tipped over one eye. *Ingomar's* captain, Charlie Barr, awaited a ruling on whether to take action to avert a collision, but the call was made to stay the course—Plant was said to have piped in, according to Massie, "By God Charlie, you're the boy. I'll give way to no man." With only three feet to spare, the *Meteor* finally gave way. The kaiser later sent an apology to Plant for the close call.

Plant's quest for winning boats also fueled some business at the renowned Herreshoff shipyard in Bristol, Rhode Island. In 1903 alone, Plant ordered four yachts from Herreshoff, costing a total of $94,000. Plant was said to

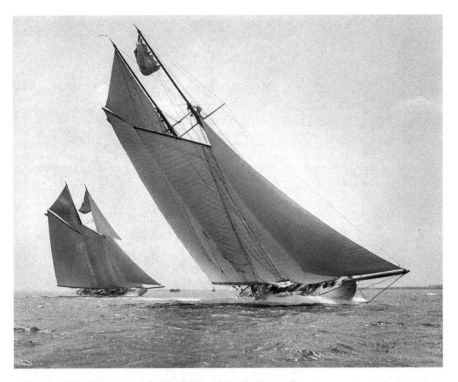

Morton Plant's yacht *Ingomar* racing *Elmina. Ingomar* won twenty-one prizes in twenty-five races and had a famous showdown with the German kaiser's yacht in 1904. © *Mystic Seaport Rosenfeld Collection, #B98.*

have convinced Herreshoff to build the first gasoline-powered launch the shipyard constructed. On the other hand, Plant knew better than to try to impose design specifications on Herreshoff.

Plant had a congenial, if unlikely, relationship with Captain Nat Herreshoff, whose personality was said to be reserved and austere, in contrast to Plant's more salty demeanor. When Plant ordered the yacht that would be *Ingomar* from Herreshoff, Plant's demands for a boat that was good and fast were conveyed with "characteristic profanity," according to *The New York Yacht Club: A History*, by John Rouismaniere. *Ingomar* was launched in 1902.

By far the most lavish of all Plant's yachts was the *Iolanda*, which was homeported in New London—a place Plant had first seen from a yacht many years earlier and where Plant's blue-and-red yacht pennant with a blue *P* inside a white shield was widely recognized. In true mariner's style, Plant's journal of his amazing trip aboard the vessel is mostly a meticulous but toneless recording of weather conditions, speed of sail and

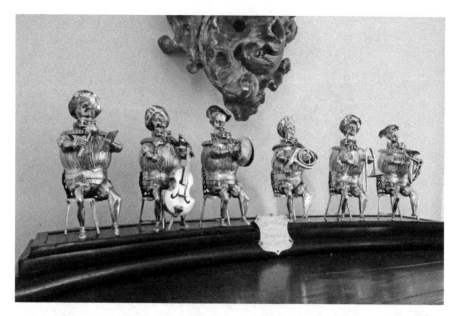

A whimsical trophy won by the sailing yacht *Ingomar*. The body of each figure doubles as a drinking vessel. *Photo taken by author.*

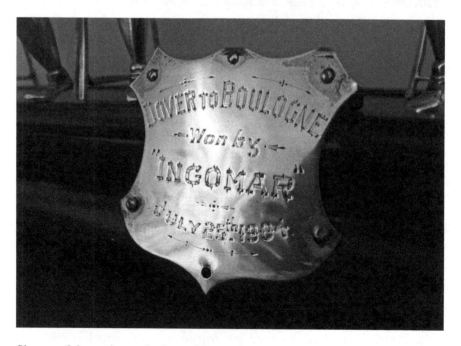

Close-up of the trophy won by *Ingomar*. *Photo taken by author.*

arrival and departure times from ports. Plant's emotions come through in only a handful of the entries. He wrote on December 14, for example, about his great anticipation at finally seeing India. But after witnessing a bridal procession for the marriage of an eleven-year-old boy to a seven-year-old girl and death rituals that included allowing flocks of vultures to descend on and eat corpses, Plant wrote on January 1, 1910, "I was very much disappointed in the appearance of the people in general, being of a much poorer class than I had expected; one sees countless wretched and emaciated people walking about."

On December 30, just a day before attending lavish New Year's Eve festivities at the Bombay Club, Plant wrote about his visit to the Temple of Silence:

> *It was the most appalling sight I have ever witnessed. Just as we were approaching, a corpse was being carried into it and our guide said that within twenty minutes the roof would be opened so that the vultures or buzzards could descend. We were quite convinced this was true, for the buzzards were already busy in anticipation, jumping about the roof. Suddenly, they all disappeared into the temple and in two hours there would be no vestige of the flesh left, the bones being cast into the lime pit, which is the ending of all good Parsis. Fortunately, we did not see this part of the procedure.*

This shocking display of Indian reality was somewhat rare for Plant's entourage, however. Instead, he wrote frequently of entertaining diplomats, princes, gentry, banking officials and business tycoons. In Hong Kong, the group was carried through the streets in chairs. In other ports, they were entertained by local dancers. They motored from the coastline to luxury hotels. He also kept a sense of humor when conditions were not quite as luxurious as the party might like. In Bangkok on January 24, he wrote the group had checked into the Oriental Hotel, and "we were soon comfortably settled, barring the mosquitoes who gave us a cordial welcome as we entered our rooms."

All was not totally jolly for Plant, however. When *Iolanda* set off on the journey, Plant also belied some personal feelings with this entry: "At 1:28 this morning, we were under way and I was out on deck looking in the direction of Branford House, which appeared to be dark, but I am sure that Mrs. Plant was watching for our departure and I only wish she were a better sailor and could have come with us, but under the circumstances it would have been a voyage of dread instead of pleasure for her."

Nellie planned to meet the *Iolanda* when it arrived in Italy around the first week of May. Presumably sailing on a much bigger ocean liner was more agreeable to her constitution. Plant noted his son Henry's arrival in Venice on May 6 and Nellie's arrival on May 8, but just two days later, Nellie decided to return to the United States after a cable relayed the news that her mother was ill with bronchitis. She and Henry headed back across the Atlantic on the SS *Deutschland*.

"This is certainly a gloomy day for me," Morton wrote of their hasty departure. "After having hurried away from Japan to meet Mrs. Plant here, she was only on board two days when she received the sad news from New York which compelled her to leave." Oddly enough, Nellie actually received a second cable before leaving, indicating that her mother's condition was improving. She headed back to New York anyway.

Nearly two months later, Plant wrote that he sent a message to his wife indicating that the *Iolanda* would soon return to New London. On July 4, Plant wrote they could not yet see land but could tell it was close. The "odor of dead fish is very keen, which proves conclusively we are to the leeward of Nantucket; no other place could possibly smell so strong."

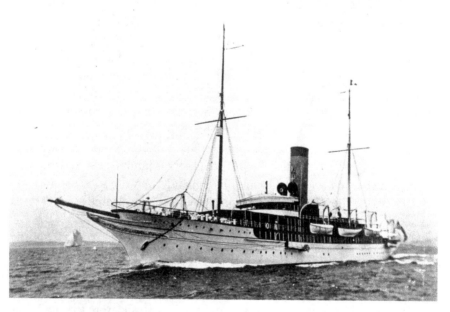

Morton Plant's steam yacht *Iolanda*, a mammoth vessel that was enormously costly to operate. *Plant Family Collection.*

On July 5, the *Iolanda* arrived at the New London custom house at 10:00 a.m. Nellie and Henry waited at the pier, and the New London populace was keenly interested in the huge ship's journey. "It has been a most wonderful voyage," Plant wrote. At the end of the cruise, and to fittingly commemorate it, Plant commissioned Horace E. Boucher to build a detailed model of *Iolanda*. Called the most dramatic model in the New York Yacht Club's collection, it provides a glimpse into the true lavishness of the yacht and puts into perspective the immense stores of coal the ship hauled.

Not long after the exotic voyage, in 1911 Plant sold the *Iolanda* to Empress Elizabeth Terestchenko of Russia, but a decision he made would lead to the yacht's seizure during World War I. Captain Charles A.K. Bertun recalled in an article published in the Wilmington, Delaware *Sunday Morning Star* in 1930 that Plant placed two rapid-fire Hotchkiss cannons aboard when Plant heard there were pirates in the China Sea. But after war broke out in Europe, being armed was reason for the Germans to intern the yacht in Norway.

The captain claimed that the ship needed repairs, however, and managed to get the yacht into the control of the British Royal Navy. *Iolanda* again ended up under British navy control in World War II, when it was renamed HMS *White Bear*, according to information from the New York Yacht Club. Following that war, *Iolanda* changed owners several more times before the majestic and ostentatious yacht was scrapped in Holland in 1958.

A SHORELINE ESTATE

The demure Nellie Capron Plant was a Baltimore native from a prominent industrialist family. She studied architecture at the Sorbonne in Paris, and although she married a man who was most at home aboard a yacht, she was prone to seasickness. Like so many women of her time, she let her husband take the lead publicly. Yet it is Nellie's talents that are showcased in one of the crown jewels of Morton Plant's Connecticut shoreline legacy: the Branford House mansion.

She worked closely with famed architect and Plant family friend Robert William Gibson to design Branford House, the family shoreline retreat that remains a prominent landmark more than a century later. The mansion boasts an eclectic mixture of architectural styles—Gothic and Flemish, with classical influence. All of it blends into a single feast for the eyes.

Nellie enjoyed just ten summers at the palatial granite mansion she was integral in designing and decorating at the mouth of the Thames River. On August 8, 1913, the *Norwich Bulletin* reported that Nellie had died the previous day at Branford House. She succumbed to typhoid fever after a three-week illness. Typhoid is responsible for two of the ten deadliest outbreaks of food or waterborne diseases in U.S. history and was common in this pre-antibiotic era when water and food were not always sanitized, even in the multimillion-dollar homes of America's wealthiest. Nellie was just forty-nine. Morton turned sixty-one ten days after his wife's death.

While Plant's beloved summer estate was the site of this tragic day, about ten months later, it also was the setting for one of the happiest. He and

his third wife, Sarah Mae "Maisie" Cadwell Manwaring, whose name was just as regularly reported as Caldwell, were married in a small and quiet ceremony at Branford House in June 1914. The *Hartford Courant* reported that the wedding, which had been scheduled for August, was moved forward to June because of the public gossip about the couple's relationship. "The ceremony was very quiet, there being neither decorations nor attendants and only a few guests," the *Courant* reported. The couple capped the occasion by attending a Planters baseball game and told the *Courant* they planned to attend the annual Yale-Harvard boat race the following day. A three-week cruise along the Maine coast was scheduled for a few weeks later.

The *New York Times's* June 18, 1914 headline about the marriage illustrates the intense public interest in Plant: "Capitalist Weds Divorcee at Branford House, His Summer Home in Groton." It also reported that Plant gave his new bride an $8 million bridal gift. It also was widely reported that the millions were paid to Seldon Manwaring as a nudge to convince him to grant Maisie a divorce. The bridal gift tale may be the more truthful story. In April 1914, a *Hartford Courant* reporter interviewed Maisie while she was living with her mother in Connecticut's capital city. She told the reporter that Manwaring was unfaithful to her for seven years and that the couple was divorced the day before the interview.

The Branford House remains one of the most prominent of Morton Plant's contributions to the Connecticut shoreline. Not only were the goings-on at the mansion and grounds the source of local fascination for years, but dozens of local residents were also employed there. Plant typically was in residence there no more than two months a year, but more than four dozen staff members worked at the house and grounds year-round. Many more were employed during the peak summer months and for the two years the house was under construction. While many of the Branford House jobs were unskilled positions such as lawn caretakers, cleaning staff and kitchen help, others required more skill and a few would otherwise have been rare in the region. Plant had a chauffeur, for example, and auto mechanics. He also trained boat pilots to ferry guests from the New London train station across the river to Eastern Point. He hired top chefs, botanists and livestock experts for his model farms, which provisioned both Branford House and his fancy Griswold Hotel.

As a yachtsman, Plant often sailed along the southeastern Connecticut coastline before buying the Avery Point peninsula, located at the southwestern tip of the town of Groton and at the mouth of the Thames River. While many of the New York socialites who were his Manhattan

neighbors headed to sprawling summer "cottages" in resorts such as Newport, Rhode Island, Plant sought enough land on which to indulge his interests in farming and horticulture. Groton had what he wanted: commanding shore views, direct water access and plenty of farmland on which to raise prize cows, pigs and chickens, along with vegetables and a range of exotic plants and flowers such as orchids, lemons and oranges.

Almost as soon as his father died in 1899, Plant began buying land at Eastern Point, the larger community just north of the Avery Point peninsula on which he built Branford House. He continued buying farms, houses and land in the area until his death in 1918, eventually controlling hundreds of acres between the Thames and Poquonnock Rivers. He first bought Thames riverfront land in the summer colony and built a three-story shingle-style house that still stands at 15 Shore Avenue. But in 1902, Nellie began work on drawings of what would become Branford House. She partnered with the architect who designed the Plants' Manhattan townhouse, and by October 1902, construction had begun.

"The first winter was cold and stormy and work of steam drilling, blasting and excavating was a fight with all the elements," architect Robert Williams Gibson wrote in a photograph album chronicling the two-year construction project. Gibson gave the album as a Christmas present to Plant in 1906. *The Day* of New London reported on some of the album's contents in a February 9, 1982 article during a period when a group of local residents was advocating the restoration of the then-crumbling mansion. The album conveyed some of the hardships and triumphs of the painstaking process of constructing the mansion. The Plants wanted the building to harmonize with its surroundings, so a first step was blasting the ledges on the rocky promontory so boulders from the site could become part of the mansion walls. On June 30, 1903, Gibson wrote, "A large firm of contractors put all their capacities to the task of getting the house up during the short season of fine weather. The amazing heaps of rock disappeared in the squared walls and by July the cut masonry began to show."

Then, on July 17, 1903: "Around the outside walls of this house is over six hundred feet and to raise the walls one yard in height involved the use of about two hundred tons of masonry which had to be moved to its location and then again handled and fitted and set; so that one hundred men would each have to move two tons of stone, &c, by hand. Thus the one yard of height was fair progress for two weeks."

Many of the laborers, stonecutters and craftsmen who built Branford House were Italians, a group that was among those transforming Connecticut

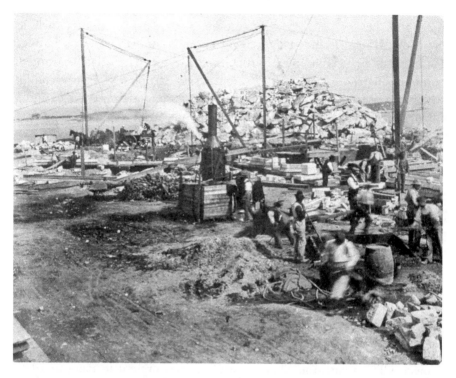

Stone being excavated and used in constructing Branford House, Groton. *UCONN Photograph Collection, Archives and Special Collections, University of Connecticut Library.*

demographics at the time. Plant brought the workers to Groton specifically for the project, and many, along with their descendants, ended up staying there and in other southeastern Connecticut towns. Italians, along with many other immigrants, flocked to Connecticut to fuel the state's burgeoning manufacturing sector around the turn of the twentieth century. According to demographic information published by the Connecticut Humanities Council, 75 percent of the state's residents were American born in 1870, but by World War I, just 35 percent were. In 1870, there were one hundred Italians in the state. By 1920, there were more than eighty thousand.

The Day reported on March 17, 1903, about five months after construction of Branford House began, that a "gang" of forty-one Italian laborers arrived at the site from Boston and another fifty-eight from New York. More were expected to arrive soon, the paper reported. The number of Italian bricklayers, masons and stone carvers rose to some three hundred, according to an article on Plant titled "The Bighearted Millionaire" published in the spring 2000 edition of *Connecticut College Magazine.*

The workers lived on site in temporary shanties that the architect called "picturesque." Photographs from the time, however, reveal the housing as miserable, small, crowded shacks. The firm of Marquardt Brothers, a Groton-based lumber and building contractor founded by a German immigrant, built the worker housing at the site. The general contractor for the work was Donato Cuozzo, a firm whose advertising at the time said the company was established in 1883 and had offices on Nassau Street in New York City and State Street in Boston. "Waterworks a specialty," the company's advertisement touted.

"The landscape work and road building was done by gangs of laborers who were housed in a picturesque village of shanties near the shore and the troubles of this colony, their opinions and mutinies and squabbles, at one time became apparently more important than the work in hand," Gibson wrote in June of 1903 in the album he gave to Plant. Gibson's passage presents a cleaned-up version of what likely was a crude and rowdy workers' camp.

While the very presence of so many foreign-born workers was unusual for a region that for so long was predominantly composed of Yankee farmers, boat-builders and fishermen, the Italians also brought other types of diversity to the region. Many were members of labor unions at a time before unions were common. Most also were Roman Catholic at a time when many Americans were at best suspicious and at worst outright antagonistic toward those of that faith.

The *St. Albans Daily Messenger* reported on December 31, 1903, that stonemasons, bricklayers and plasterers were on strike at Branford House over the refusal of three members of the Operative Plasterers Association to join the International Bricklayers and Masons Union of America. While there is no evidence that Plant got directly involved in labor disputes and nothing that points specifically to his opinion of unions, Plant did take steps to keep his workers happy. He sent to Italy for specific types of food while the workers were on site and later donated the land on which Groton's first Catholic church was built.

By the summer of 1904, the mansion was complete. It cost some $3 million, an amount that in 2016 dollars would be more than $77 million. Its significance to the region and the way it transformed the neighborhood is illustrated in an April 6, 1905 article in *The Day* under the headline "Skillfully Applied Wealth Has Created Grand Palace by the Sea."

"That an imposing pile, rivaling in architectural beauty and massive grandeur some of the more famous English mansions would arise in this seemingly barren and waste piece of land was little dreamed of a few years

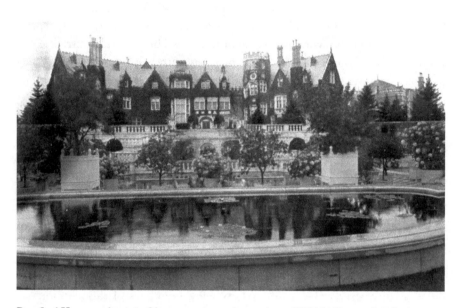

Branford House and some of its once spectacular gardens. *UCONN Photograph Collection, Archives and Special Collections, University of Connecticut Library.*

ago," the article reported, noting that Avery Point was previously a vast "area of barren rock and wilderness." The house had thirty-one rooms built on a reinforced concrete foundation, a new concept at the time. The interior featured a two-story fireplace and a winding staircase of imported Italian marble, with hand-carved mahogany, oak and walnut paneling and trim. Marble, sandstone, onyx and bronze prevailed. There were eleven bathrooms, some with marble safes and bronze- and silver-plated hardware. One room was dedicated to arranging cut flowers, and the mansion included an elevator, a pipe organ and a basement clothes drying system unique for the era. One entire room, which would become the music room, was imported from Cornwall, England—dismantled, shipped and reassembled in Groton.

The grounds also made Branford House particularly special. *The Day* called them a "triumph of landscape gardening" and noted that the superintendent of the estate was one of the foremost horticultural experts in the country. Eventually, Plant added numerous outbuildings on the site, including at least two enormous greenhouses with distinct sections for growing nectarines, grapes, strawberries, oranges and other fruit. There

also was a gate lodge that mirrored the architectural style of the mansion, two stables and several barns. There was more than six thousand linear feet of underground electric wiring outdoors, two electric light plants with a capacity to illuminate three hundred lights each and dedicated firefighting apparatus and hydrants. The employees were grouped into firefighting companies and regularly practiced fire drills.

"Considered in its entirety, the impression conveyed to the mind is that by all this vast outlay of wealth, Morton F. Plant will not only obtain an inestimable amount of pleasure, but will at the same time directly and indirectly benefit hundreds of families," *The Day*'s April 1905 article reported.

A map prepared just before the sale of the property in 1939 shows the main Avery Point tract of forty-one acres encompassing the mansion, sunken gardens and eight outbuildings. Another sixteen-acre tract on the north side of Eastern Point Road included nine more buildings, several dedicated to housing employees. There also was an elaborate guest house and a lake. The third parcel was the thirteen-acre Pine Island, where Plant's sheep sometimes grazed and his grandchildren later played.

Plant's gardens—with fountains, statuary, potted palms and ornately carved marble banisters and stairs—were reminiscent of Louis XIV's palace at Versailles, France, although on a smaller scale and minus, of course, the famed Hall of Mirrors and the tumultuous political associations. Plant, who had Italian topsoil shipped to Groton for his exotic plants, nurtured prize-winning orchids in his greenhouses. In 1906, it was reported that he saw a purple beech tree in Norwich, about twenty-five miles north of Branford House. He promptly hired a team of twelve horses and their drivers to haul it south to his estate.

On July 27, 1911, the *Hartford Courant* reported on some of the society happenings at Branford House with the headline "Mrs. Plant Hostess at Branford House; Most Elaborate Social of Summer Season." The article reported, "By far the grandest and most elaborate social function attempted this year was the reception given on Monday afternoon by Mrs. Morton F. Plant at her mansion, the Branford House. About seventy-five attended, many of whom were from the Pequot Colony (in New London). The house was beautifully decorated and the music was furnished by the Griswold orchestra under the direction of G.W. Phillips."

Besides the wow factor of the estate, for the local community, the most important aspect of Branford House was the employment and other economic opportunities it afforded. Tom Cataldi of Groton, the longtime owner of Tommy's Flowers, recalled in 2015 that when his father worked on

the Plant estate prior to World War II, his dad frequently came home with a large container of ice cream for the family. Cataldi also recalled enjoying oranges from the Plant greenhouses, even in the dead of winter. Joe Pezzillo told University of Connecticut student Elizabeth S. Dutka for her May 1989 thesis, titled "People of Avery Point," that he worked at the Plant estate from the age of ten. His father was head gardener there, and Pezzillo recalled that there were about sixty gardeners working at any given time.

The Plants also frequently gave local schoolchildren bouquets of flowers from their greenhouses, and locals looked forward to picking the leftover potatoes from Plant's fields once the larger tubers were harvested.

The Plants also demonstrated their largesse to the community in other ways. On June 18, 1918, *The Day* reported that Plant bought an Eastern Point property known as the Watson House and gave it to the U.S. Navy for use as a military hospital. Plant also donated $10,000 to the hospital's operations. When the 1918 flu epidemic claimed Plant's life, the mansion went to Plant's son, Henry. Henry's wife, Amy, loved Branford House and frequently lived there with her two daughters. Morton's will provided financial accommodation to keep the estate operating as long as Henry and Amy lived there. When Henry died in 1938, however, Morton's widow,

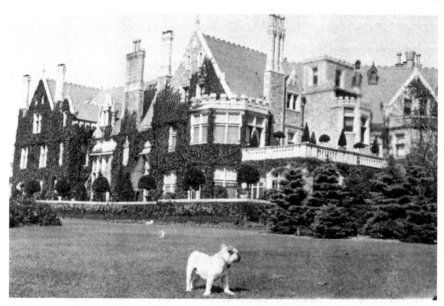

A pet on the lawn at Branford House. Ivy once covered its façade. *Plant Family Collection.*

Maisie, fought for her claim to the estate, and eventually Amy and Maisie were counseled to sell the estate to avoid a protracted legal battle. The house, land and contents were painstakingly inventoried and sold by the Parke-Bernet Galleries of New York City. The auction book for the sale includes long lists of furniture, rugs, tapestries, clocks, lamps, porcelains and other items, including 112 lots of greenhouse and garden plants. Amy reportedly purchased many objects to ensure that they remained in the family.

The unfortunate timing of Henry's death, as the country was still reeling from the Great Depression and before the outbreak of World War II, made the estate a white elephant. An appraisal dated May 31, 1940, by the George P. Horan Company of New Haven valued the property at $100,000. Branford House was sold at auction for a mere $55,000 to the State of Connecticut. During the war, the state turned the land over to the Coast Guard, and in the fervor of war preparedness, it bulldozed much of the lavish Plant gardens into the sea. A Coast Guard training center operated at the site until 1967. That same year, the Coast Guard training center closed, and the University of Connecticut opened its southeastern Connecticut branch campus there.

While the Branford House remained a community showcase and the site of many important social events, such as submarine launching parties, the university made few financial investments in the mansion in its first two decades of ownership. In the 1980s, a group of local residents fought strenuously to wrest control of the mansion from the university and restore the building to its former glory. The group's leadership splintered after a multiyear fight. But for the Branford House itself, the end result was mostly positive. The university invested money to repair the mansion and continues to host community galas, exhibitions, proms, weddings and other events there. The public is still able to enjoy a spot that is one of the most beautiful in southeastern Connecticut.

MODEL FARMS

On August 5, 1917, Connecticut's main daily newspaper reported the state was in the throes of "one of the worst milk situations ever experienced." A milk shortage had already boosted milk prices to twelve cents a quart for consumers and threatened to push the price up to fifteen cents a quart, the *Hartford Courant* reported. In comparison to other food items at the time, the cost of milk was precariously high. New London's Mohican Market was selling eggs for thirty-nine cents a dozen, bacon for thirty-eight cents a pound, butter for forty-four cents a pound and four cantaloupes for a quarter. Irlandi's Grocery, also located in the city, was selling five pounds of flour for forty-four cents and ten pounds of sugar for eighty-eight cents. The rising price of milk was the subject of many news reports, and there was widespread worry that cash-strapped parents would be unable to provide the beverage for their infants and children.

Causes for the shortage were many. The number of small family farms in Connecticut had sagged in the years since the Civil War as the state's reliance on its agricultural economy declined. Connecticut was a heavily industrialized state by the pre–World War I years. For those farmers who remained in business, production costs rose, and a lack of cooperative efforts among farmers, suppliers and distributors boosted costs. Farmers also said they could no longer buy good milk cows. The *Farm Bureau News*, a publication of Storrs Agricultural College, the school that later would become the University of Connecticut, reported in July 1917 that state farmers were producing milk at a financial loss for an entire year. At the

August meeting of the Connecticut Milk Producers Association, worried farmers learned that the amount of milk stock throughout the Northeast had declined by 6 percent.

Few farmers could work at a financial loss for indefinite periods. Not so Morton Plant. At the height of this crisis, he bought thirty-six new milk cows to add to his Groton herd. He did so "in order to help out the supply of milk, which has been so short of late it has caused serious troubles to the people of the city," *The Day* of New London reported on August 6.

By this time, Plant's largesse and celebrity already were well known and widely publicized. He never made public all the reasons he was attracted to southeastern Connecticut decades earlier, but locals long speculated that one reason was the vast amount of open land still available in the region. The fertile shoreline fields bordering Fishers Island Sound were a perfect place for him to transition from global sailor to gentleman farmer, and he had been impressed by a local model farm run by another New York businessman, Caleb Haley. By establishing his summer mansion and hotel-resort in Groton and shunning the well-developed, wealthy playgrounds, Plant could help shape the region as he wanted.

Farming was predominant in Connecticut from the time of the first European settlers and well into the nineteenth century. Most of the state's families continued to either farm themselves or had a close personal link to farming. During and just after the Civil War, however, industrialization exploded. Between 1870 and 1900, Connecticut manufacturers nearly doubled, from about five thousand to nine thousand. In the same time, the gross product of Connecticut industries grew from $161 million to $350 million.

The state's urban centers became densely populated and often miserable places to live as waves of newly arrived immigrants crowded into cities to work in a wide variety of industries. As more people packed into housing that frequently was devoid of adequate sanitation, ventilation and heat, urban slums became breeding grounds for diseases. Outbreaks of smallpox, cholera, typhus, diphtheria and tuberculosis were common. Nostalgia for the supposed good old days of farming grew, despite the reality that farming was back-breaking, dirty and dangerous work. At the heart of the state's establishment of the Storrs Agricultural School in 1881 was a desire to retain and revitalize the state's farm economy. The intent was to educate farmers' sons and daughters about farming technology, the science of agriculture and upkeep and management of the farm home. There also was much consternation among Connecticut's residents that Yale University,

which was at that time the state's land grant higher education institution, was graduating few scholars intent on agriculture-related careers. For about twenty years, Plant's farms provided agri-scientists, veterinarians, landscapers, building technicians, botanists, farm laborers and others with plenty of work.

Plant began buying land in southeastern Connecticut in the late 1890s. He eventually acquired some six thousand acres (about ten square miles) of land in two separate towns on which he stocked game, stabled horses and raised herds of sheep, pigs and cows, along with flocks of chickens, turkeys, ducks and geese. Plantford Farms was located in the town of East Lyme, about fifteen miles west of Branford Farms in Groton, which was close to Branford House.

Although the farms were a curiosity in the region and a playground of sorts for Plant's wealthy friends and acquaintances, including hotel guests and business associates, farming was also a serious business and a public service for Plant. A 1913 article in the *New York Times*, under the headline "Model Farm One of Connecticut's Proudest Boasts," reported:

> *Farming on a large scale in New England is now spoken of as a thing of the past. For years the cry has been to go West or go to Canada. Acreage, quality of soil, and a dozen other theories are advanced as reasons for leaving New England as a location for profitable farming. There is not a State in beautiful, historic New England that is not strewn with the wrecks of homes and deserted farms. Failure in farming in New England has been a matter of imperfect method rather than soil conditions. Year after year crops were sown and gathered till the exhausted soil could produce no more. Little attention was given to fertilization, and the buying of especial kinds of commercial fertilizer for particular soils and crops was almost unknown. Out of these conditions grew the belief that successful farming in New England was impossible. It has devolved upon Commodore Morton F. Plant to prove the fallacy of this belief.*

Plant strove for agricultural perfection by employing contemporary farming methods to breed the strongest and most productive stock, and he was rich enough to purchase livestock that would strengthen his herds. At one point, he owned more than three hundred Guernsey and Ayrshire cows. The *Times* reported that Plant was likely to narrow his stock to the Guernsey alone because "[i]t is Commodore Plant's ambition to make Branford Farm produce the highest-bred cattle in the United States."

An advertisement for Branford Farms in a 1911 edition of the *Guernsey Breeders Journal*. Plant's model farm was known for its high-quality cattle. *American Guernsey Association, Columbus, Ohio.*

In 1911, Plant bought twelve head of cattle at a sale near Villanova in New York, spending $12,775. "Society women were present at the sale which attracted fanciers from all over the country," *The Day* reported. Among his purchases was a blooded bull for which Plant paid $3,200, the highest price ever recorded for such an animal. In comparison, most workers at the time earned less than $1,000 a year.

Plant's pursuit of the best milk-producing cows also took him across the Atlantic. He bought cows directly from the Island of Guernsey in the English Channel. "Walter Jauncey, who is Commodore Plant's Superintendent of cattle-raising, has spent his life in studying the breeding of pedigreed stock. In his opinion, the Guernsey cow outweighs all others in desirability. The cost of producing 5 percent milk from the Ayrshire cow is one-third greater than that from the Guernsey and the latter is a persistent milker, the period of lactation being much greater than in the Ayshire," the *New York Times* reported.

In pursuit of bovine perfection, Plant paid another $2,000 for a single Guernsey bull and directed his farm workers to execute exacting standards with every calf born on the farm. "To avoid the chance of one drop of 'brindle' blood," the *Times* reported.

This exactitude carried over to all types of livestock Plant raised. He sought the most prolific of laying hens, the heartiest of turkeys, champion pigs and a flock of Shropshire sheep. "The original stock from which the sheep flock is being bred were imported from England and are of the purest blood that could be secured," according to the *Times* article. "Rams costing more than $500 apiece head the flock. Many prize winners are members of this flock and record-breaking wool producers compete at the agricultural exhibits for the prizes for the largest clip," meaning the most wool produced per sheer.

In the years before World War I, Plant livestock, fowl, vegetables and flowers earned prizes at agricultural exhibits, contests and fairs throughout New England. In 1913, a single Plant cow produced more than eleven thousand pounds of milk, a record at the time. Plant proudly displayed trophies and ribbons in his barns. The farms also helped ensure a measure of self-sufficiency in the region. Meat, dairy products, vegetables and eggs eaten by guests and residents of the Griswold Hotel and Branford House were all products of Plant's farms. Food also was shipped to his Manhattan townhouse. There were some eleven thousand hens on Branford Farms in 1914, and *The Day* reported that the "call for chicken from the hotel, mansion, cottages and help is enormous."

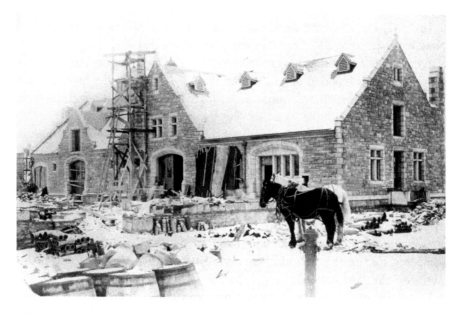

A barn under construction at Branford House. Plant housed his livestock in high style. *UCONN Photograph Collection, Archives and Special Collections, University of Connecticut Library.*

The stock was prolific not only because of sound breeding. Plant's livestock was housed in far superior conditions compared to other farms and better than many homes of the time. Grain and feed were grown on site, with its quality under the constant scrutiny of scientists. The cow barns at Branford Farms were sturdy, ornate granite structures. "To house this herd of pedigreed stock," the *Times* reported in June 1913, "in a fitting manner has been the work of H.R. Douglas of New London. Steel, stucco, concrete, and gray shingles are the materials used in the construction of all the farm buildings. Every known device for good sanitation and equipment has been installed."

The barns featured electricity, hot and cold running water and steam heat at a time when many homes did not have these systems. "The equipment of the cow stable probably shows the most skillful architectural handling," the *Times* reported. "Here even the ventilation is a matter of scientific arrangement. Windows there are in plenty, but to adjust the cool air properly in cold weather, a system of ventilators is employed."

The *Hartford Courant*, in October 1914, wrote, "At both the Branford and Plantford Farms, the equipment is the best that can be bought. Cement barns, finished on the exterior in stucco and on the interior in smooth plaster and hardwood, concrete floors, metal stanchions, plenty of running water

both hot and cold, steam heat—all makes for the comfort of the pampered stock which is housed there."

Plant also had the means to fight agricultural scourges that other farmers could not. In July 1914, the *Hartford Courant* reported that some fifty laborers under the direction of a Connecticut Agricultural College professor were fighting an army worm invasion threatening Plant's $10,000 corn crop. The workers dug trenches and filled them with a poisonous mash to kill the worms.

Plant also had his farms engineered to be as highly mechanized as possible. Automatic milking machines, invented only in 1894, were used. A system of mechanized conveyor belts assisted in feeding the hens and harvesting eggs. What the papers called pampering—daily grooming, regular cleaning of water bowls and careful recording of health histories of each animal, along with carefully regulated cooling of milk and sterilization of containers—also meant that the products from Plant's farms were of a high quality and more likely to be healthier, free of the types of contaminants common at the time. Plant kept new animals isolated until he was certain they were disease free and even moved his entire herd of Berkshire pigs from Groton to East Lyme at one point to help ensure the animals did not contract cholera, a disease sweeping through swine populations at the time.

"The vegetable kingdom is not neglected at the farms and fine varieties are grown by improved methods, much of the latest machinery being used," the *Courant* wrote. "The great crops of corn and potatoes are all utilized by the various establishments which are maintained by Commodore Plant. Much of the corn goes into the big silos of the farms and the hay crop goes into the big lofts. Potatoes and garden truck supply the big tables which are set for the help at the two farms."

His farm workers enjoyed not only plentiful fresh food but also economic stability; clean, safe housing; and high-quality work conditions. "The working staff of this estate is a village of itself," the *Times* wrote. "Superintendents and heads of departments occupy private houses [supplied by Plant], while a spacious boarding house is conducted for the farm workers. Artesian wells furnish an unlimited flow of water, so that every barn and every house is equipped with all conveniences." Branford Farms superintendent R.H. Ortez had his own touring car and chauffeur.

Despite the farms' high standards, or perhaps because of them, as a business they ran perpetually in the red. There is little doubt, however, that Plant firmly believed there was a greater good to these expenses. In writing his will less than a month before his death, Plant directed the farms continue to operate from the proceeds of his estate, even if at a financial loss.

PLAY BALL!

On January 6, 1913, Morton Plant wrote a letter to John Morrell of the famed sports equipment and apparel company Wright & Ditson in Boston, saying, "Wonders will never cease: I have obtained the baseball franchise for New London, Connecticut, where I live, and have secured quite a number of good players."

Plant was still scouting for more players, however, because the purpose of his letter was not to inquire about bats or uniforms. Plant asked Morrell's opinion of two players Plant was courting: Fred Ulrich and Joseph Briggs. Ulrich was a catcher who had ten minor-league seasons under his belt by 1913. Briggs was an outfielder with eight seasons of play behind him. While local lore has it that Plant lured and retained players by offering them more lucrative salaries than did other teams, including those in the Major Leagues, Plant's letters indicate that he offered a collegial lifestyle rather than wealth. Besides, league rules limited team salaries. According to a February 5, 1913 letter from Plant, league regulations stipulated total team salaries couldn't top $2,500 a month.

In a January 24, 1913 letter to Ulrich, Plant flatly refused to pay the player, who was then living in Newcastle, Pennsylvania, more than he had earned from his previous team in Lawrence, Massachusetts. In an effort to secure a more lucrative contract, Ulrich returned Plant's initial offer unsigned. Ulrich contended that his playing record in Lawrence was evidence he deserved more money. Plant agreed that Ulrich's playing was superb but held firm on his original financial offer.

"We of the New London Club are a happy family; there has never been any dissension among its players, nor do I expect there will be—our policy being to do right to everyone," Plant wrote. Then Plant demonstrated some of the business acumen his father had apparently not appreciated. Ulrich should inform Plant if the player didn't want to sign on to the New London team, Plant wrote, contending that he was already eyeing another player. Apparently, Plant's offer was enticing enough for both Ulrich and Briggs to come to New London. Both are listed on the team's 1913 roster.

Plant's team was called, appropriately enough, the Planters, and it was a source of tremendous local pride. While minor-league baseball no longer holds much star appeal, in the years before World War I, it was an immensely popular sport and players enjoyed local celebrity. The emerging middle class and the burgeoning number of factory workers were enjoying more leisure time, but travel far from home was financially out of reach and too time consuming for most American families. In-home radio entertainment would not begin to take hold for more than another decade. Americans of the era instead spent their off-work hours in community, church and social club diversions, including dances, picnics and baseball.

The Planters club was not New London's first baseball team. Baseball historians Bill Weiss and Marshall Wright, in an article published on the MiLB.com (Minor League Baseball) website, said that the Whaling City's first team was the Pequot club, which began playing around the time of the Civil War. The city's first professional team, called the Whalers, was formed in the 1890s. It survived, despite a mediocre playing record, until 1907. Another, more successful Whaler team lasted only the single season of 1910. Plant apparently also owned the 1910 Whalers. The Henry B. Plant Museum's Tampa, Florida archives includes a collection of letters Plant wrote about his teams. They begin in 1910 and extend through March 1913. Each ends with a stamped signature of Plant's name in bold block letters rather than a handwritten signature.

Plant wrote about some of the oddities of minor-league baseball in a December 31, 1912 letter. He recalled that a previous New London team owner only retained players who would gamble their earnings in the team owner's poker rooms. The team, Plant said, never broke even financially. Plant took a different course. "By treating these players as we did they now show their appreciation by signing with us for less money than they would sign elsewhere," he wrote.

In 1913, the Connecticut State League was reformulated as the Eastern Association with four Connecticut teams, plus three from Massachusetts.

Plant helped put New London back on the baseball map. He focused much attention not only on recruiting top players but also on ensuring a fine management team and a ball field both the team and the city could be proud of. The Planters regularly packed in crowds for the games at Plant Field, located in an area that is now a residential neighborhood of houses along Plant and Morton Streets. The team and its ancillary activities also helped fuel the local economy.

New London druggist Charles S. Starr was the team president and Waterford resident J.J. Burns its manager. According to correspondence about the team between Plant and numerous others, player salaries ranged from $85 a month to $200 for top-notch players like Ulrich. In addition, Plant paid up to $500 in signing bonuses and paid travel expenses from their homes to Connecticut.

The American Enterprise Institute lists the average 1913 U.S. income at $750. The team members played a 140-game season extending from April through early September, meaning top players earned salaries well above average among their contemporaries. Most players earned $150 or $175 a month, putting them at just about average in terms of earnings, but considering the number of their contemporaries who risked their lives daily on jobs in factories or farms, earning an average salary to play baseball was likely considered a great way to make a living.

In addition to paying his players, Plant had other expenses connected with operating the club. In a January 15, 1913 letter, he wrote that he purchased real estate known previously as Armstrong Park for $20,000 and paid New London contractor WL Poe $1,775 to build the grandstand. He also paid a groundskeeper $450 to work a six-month season. The city's downtown hotel the Crocker House provided room and board for the players.

The players' uniforms were bluish gray, with "New London" emblazoned across the front of their shirts, according to a February 8, 1913 article in the *New London Telegraph*. Players also were provided heavy gray sweaters, no doubt needed for early season practices in the still frosty shoreline Connecticut air.

While Plant worked to build community loyalty to the team, he also kept a business perspective. In response to a request that he erect a particular type of fence around the field that would allow boys to view games from outside the fence, he wrote on February 3, 1913, to H.F. Grieshaber of New London, "While I desire that all of the young boys have an opportunity to see the game, you must bear in mind that the Club is under heavy expense in maintaining its players, etc."

According to MiLB.com, the Planters ended the first season one game under .500, but in the 1914 season, they had an 81-35 win-loss record. Unfortunately, the team momentum then was put on hold for a season as the league was reformulated yet again. The Eastern League comprised teams extending from Maine to Connecticut, and league play resumed in 1916.

The games were a place to show off local pride, as evidenced by an August 1916 event called Elks Day. The *Norwich Bulletin* reported on August 26, 1916, that in addition to the regular game-day crowds, five hundred Elks waving purple pennants and wearing purple badges paraded onto Plant Field. More than two thousand people were in the crowd, and Plant was presented with a floral baseball nine feet in circumference made out of more than one thousand red and blue asters.

While no Planters player had the star quality or playing ability of the top players of the era, such as the Detroit Tigers' Ty Cobb, the team had some notable members. One was Bunn Hearn of North Carolina, according to MiLB.com. In 1914, as a member of the world-touring Giants team, Hearn was summoned during an exhibition game in London to explain pitching to Britain's King George V. Hearn later earned much acclaim coaching the University of North Carolina's baseball team to six conference titles and two championships in fifteen seasons between 1932 and 1947.

Gene McCann is another notable baseball man with a Planter affiliation. He pitched for the Brooklyn team in 1901 and 1902 and then managed several Northeast teams, including the Planters in the 1913–14 and 1916–17 seasons. Between 1927 and 1941, he was a highly regarded scout for the New York Yankees.

In the 1916 season, the Planters also boasted that Harry "Bud" Weiser was on the roster. He stole a team high of fifty-five bases and later briefly played in the majors for the Philadelphia Phillies.

By the 1918 season, the United States' entry into World War I, the draft and the relatively high salaries being offered to factory workers at the time left all minor-league teams struggling. Just a month before the season opened, the *Hartford Courant* reported that no team in the league had even half a roster of players. When the season began, however, play remained lively and theatrical. The *Courant* reported on June 19, 1918, that the Planters were fined $100 for forfeiting a June 14 game to Bridgeport. The Planters had walked off the field in the first inning after what the *Courant* reported as "war talk" and repeated protests about the umpires' rulings. Three individual Planters' players also were fined because of their on-field actions, causing the game to be forfeited.

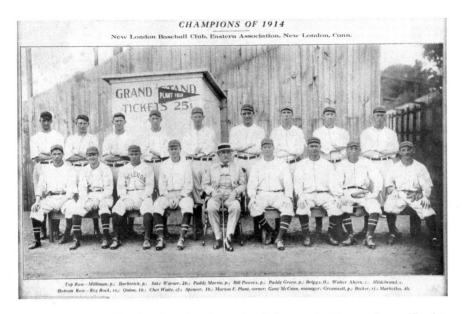

CHAMPIONS OF 1914

New London Baseball Club, Eastern Association, New London, Conn.

Top Row—Milliman, p.; Barberich, p.; Jake Warner, 2b.; Paddy Martin, p.; Bill Powers, p.; Paddy Green, p.; Briggs, lf.; Walter Ahern, c.; Hildebrand, c. Bottom Row—Roy Rock, ss.; Quinn, 1b.; Chet Waite, cf.; Spencer, 1b.; Morton F. Plant, owner; Gene McCann, manager; Greenwell, p.; Becker, rf.; Marhefka, 3b.

Plant poses with his New London minor-league baseball team, the Planters. *Lyman Allyn Art Museum, New London, Connecticut.*

The 1918 season ultimately was truncated due to the war, and minor-league baseball would not regain its local cachet in New London. Plant's death in 1918 put an end to the Planters, but in its brief history, the team claimed two pennants for its home city and was the source of baseball lore for generations to come.

A Shoreline Trolley

O n a Monday evening in August 1917 in rural North Branford, Connecticut, a trolley motorman with sixteen hours of work already behind him succumbed to drowsiness and failed to pull off at a rail switch. That fatal mistake put him and his passengers on a head-on collision course with a speeding electric trolley heading in the opposite direction on the single track. Just before the two cars crumpled into each other in a tangle of splintered wood and twisted metal, the previously drowsy motorman dove off his trolley to safety. The other motorman was crushed to death, along with eighteen others in the packed cars.

The following morning, news of the horrific crash was played prominently on newspaper front pages in Connecticut and throughout the region, sharing top billing with reports from the battlefields of Flanders. "Cars Telescope at North Branford, Mangling Passengers," the *Hartford Courant* headline read, while the *Morning Herald* of Gloversville, New York, proclaimed the accident the "worst trolley crash in history of New England."

With a federal investigation looming, it took little time for the trolley company's general counsel to deny that the motorman worked such long hours. The lawyer told the *Hartford Courant* on August 15 that a motorman's average workday was just nine hours.

While the accident was a tragedy for those who lost loved ones or were injured themselves, it also was among a series of misfortunes that led to the 1919 demise of the Shoreline Electric Railway, the struggling company that operated the ill-fated cars. It was owned by Morton Plant. Shoreline

was an interurban trolley serving coastal resorts and remote rural outposts between New Haven and Westerly, Rhode Island, and north to Willimantic and Coventry, Connecticut.

While the accident was a blow for Shoreline, the trolley company was dealt a more severe calamity about a year later when Plant died. The line continued to run for another year after Plant's death, but it was that event that ultimately caused the line's demise. The North Branford accident, a strike by trolley employees, a major power outage at the Shoreline power plant and another serious accident in which a dozen were injured at the Waterford, Connecticut village of Oswegatchie were contributing factors. The cumulative weight of these troubles proved too much for the line to endure, especially without the capital Plant continuously pumped into the company.

That Plant ended up as a trolley line owner was no surprise. Plant was born into the transportation business. His father built a dynasty with his network of railroads and steamboat lines, connecting the many short lines of the South with one another and linking the lines with major steamboat terminals. Henry Bradley Plant's shrewd timing and business prowess allowed him to amass a fortune. He also understood how to fuel more business for his railroads and ships by building posh resorts in remote reaches of the Florida swampland. Morton Plant followed his father's lead in many ways and continued in the businesses in which he was trained. Some of Morton's ventures, however, including the Shoreline Electric Railway, held more popular appeal than financial success.

Still, Morton Plant's instincts that better transportation would fuel a more robust economy in eastern Connecticut were sound. A 1916 guide to trolley travel called the Groton shoreline "a country that never grew up." Plant sought to extend trolley service along the Connecticut shoreline as a means to attract more development there. For ordinary citizens, interurban trolleys provided a relatively inexpensive means to travel farther faster than ever before. Transportation improvements occurred just at the time a growing segment of the population, including those who toiled long hours at the many textile factories in the region, were enjoying enough leisure time to make day trips to parks and the seashore.

Well into the second half of the nineteenth century, there was little ability or reason for many New Englanders to stray very far from their home villages or farms. While New England had enjoyed some of the best transportation networks in the country since colonial times, the slow pace and high cost of travel, combined with exhausting work schedules, made travel and leisure

pursuits relatively rare, especially given the Puritan work ethic that viewed leisure with suspicion.

Still, a crude road system and then a network of more sophisticated and smoother toll roads over which public stagecoaches ran regular routes meant that travel was possible for those who needed to journey between cities. When steam railroad lines began linking both large and small cities, more travel possibilities opened. "Nothing was more important to New England transportation history than the completion of a railroad route between Boston and New York City," Gregg M. Turner and Melancthon W. Jacobus wrote in the book *Connecticut Railroads: An Illustrated History.*

By the mid-1880s, a train route linked Boston with the small seacoast town of Stonington, Connecticut. Steamboat lines further linked Stonington to New York City. Long Island Sound was a busy thoroughfare, as several companies' steamboats regularly ferried passengers between Stonington and New York City. While trains and steamboats provided wealthy families and an increasing number of white-collar workers the opportunity for more frequent travel, most Americans did not have the financial means for such luxury.

The trolleys, however, with a basic fare of a nickel in Connecticut (about $1.50 in 2016), opened up opportunities to the working classes. While city dwellers had traveled by horsecars or electric streetcars within city limits for decades, it wasn't until interurban lines were built that it became reasonable for a factory worker in Norwich, New London or some of the smaller mill villages along so many eastern Connecticut rivers to head for a day trip to Connecticut's seaside villages and resorts in Niantic or Ocean Beach or to Watch Hill in nearby Rhode Island for some refreshing sea air and sunshine. They also could now leave their small towns or farms to shop for a few hours in Norwich or New London. The interurban lines also carried children to school, residents to recreation fields such as Plant Field in New London to watch baseball games and workers to offices and factories, not to mention freight, the mail and even perishable food items such as lobster and milk.

In the book *Trolleys*, Ruth Cavin wrote that interurban trolley fares were half or two-thirds lower than the cost of taking a train, and in rural areas the trolleys stopped on demand. All a potential passenger had to do was stand near the track and wave or light a newspaper on fire at night, holding it aloft as a signal to the motorman.

As with so many of the ventures on which his legacy is built, Plant delved into the street railway business soon after his father's death. In 1900, the Shoreline Electric Railway had thirty-two miles of track from Stony Creek,

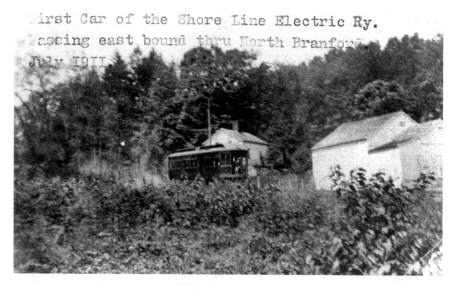

irst Car of the Shore Line Electric Ry.
assing east bound thru North Branford.
July 1911.

A car from Plant's Shoreline Electric Railway, an interurban trolley line. *William B. Young Collection of the Connecticut Company, Archives and Special Collections, University of Connecticut Library.*

a village in the Plant family's hometown of Branford, to Ivoryton, a section of Essex on the Connecticut River, according to an October 1985 article by Randal L. Clampett titled "On the Trail of the Shoreline Trolleys," published in a magazine called *Heading Out*. Plant invested heavily in Shoreline and ultimately took control of it, building it by 1911 into a railway with a main line of forty-eight miles of track from New Haven to Ivoryton, boasting its own mammoth powerhouse on the Connecticut River in Old Saybrook. Plant's Shoreline became the fifth-largest trolley system in New England.

A big jump in the Shoreline's growth resulted from the misfortune of another railroad. In the book *Images of Rail: New London County Trolleys*, put together by the Connecticut Motor Coach Museum, Plant was said to have secured much trolley infrastructure as the result of a 1914 investigation by the Interstate Commerce Commission, although in 1912 it was reported that Shoreline had already bought the Groton and Stonington Street Railway. The ICC investigated the New Haven Railroad, which owned extensive interurban trolley systems in New England, for conspiracy to violate antitrust laws. After company officials were indicted, the railroad was forced to dispose of extensive holdings in Massachusetts, and Shoreline stepped in with an offer to lease all its eastern Connecticut holdings.

This put another ninety miles of track, 134 cars and five car barns under the control of Shoreline for an annual rental cost of $247,500. For the riding public, the deal meant little except the trolley cars were now painted Shoreline's signature green. For the company, however, it meant a seamless connection with lines north in Worcester, Massachusetts, and east in Rhode Island. Shoreline now controlled lines to the Connecticut towns of Coventry and Putnam, as well as the surrounding rural interior of eastern Connecticut and along the shoreline between New Haven and the Westerly, Rhode Island summer resorts. By 1914, adjacent interurban lines allowed for trolley travel between New York City and Boston. The fare for traveling that distance was $3.75.

The Shoreline's cars, built by the Jewett Company of Newark, Ohio, were popular with riders. They were heavy and more comfortable than other trolleys, and each had two compartments, one for smoking and one non-smoking. Each car could carry fifty passengers. In 1912, at an annual meeting of an Electric Railway Society, one member remarked about the Shoreline, "I have had the opportunity of riding over the road a good deal and those of us who have ridden on the road realize that we have a thoroughly modern, up-to-date trolley road there." Most interurban lines followed public highways or traveled over private rights of way, and the Shoreline was no exception. Cars could reach speeds of up to eighty miles per hour.

Travel booklets from the time encouraged the public to travel by trolley. One January 1915 booklet, for example, advertised trolley excursions between Norwich, Connecticut, and Watch Hill, Rhode Island, with trolleys running every half hour between 6:25 a.m. and 10:45 p.m. The trip took one hour, thirty-five minutes each way, a distance that can now be traveled in a car in about forty minutes. Some guides also advertised overnight accommodations for trolley passengers at a cost of $2.50 to $3.50 a night for a room at New London's Crocker House, for example.

While trolleys remained popular with the public, most lines never were self-sufficient. The infrastructure costs were immense and included upkeep of the rails; operation of expensive power plants; employment of crews of mechanics, motormen and others; maintenance of cars and car barns; and compliance with specific regulations. The February 7, 1914 edition of the *Electric Railway Journal*, for example, detailed an order to Shoreline to lower the steps on all its cars. The bottom step was to be no higher than sixteen inches above the rail, a regulation that cost the company time and money to install steps of the proper height.

Most trolley workers took immense pride in their work, but the hours were long and the work dangerous. There were frequent reports of workers killed in trolley accidents or crushed between cars while moving in car yards. Workers' unions regularly pushed for increased wages, and according to the Connecticut Motor Coach Museum book, salaries rose quickly in the years just before World War I, from thirty cents an hour in 1915 to forty-two cents an hour three years later. This salary still was below the salaries of other workers, however. Government workers in 1918 earned an average of forty-nine cents an hour and those in manufacturing fifty-three cents an hour, according to the U.S. Bureau of Labor Statistics.

Probably the biggest threat to the trolleys, however, was their competition. The ascent of trolleys occurred at the same time automobiles were becoming increasingly popular and affordable. While automobiles were the stiffest competition, recovery from grim and fairly frequent accidents also left interurban lines shaken. While reports of Plant's reaction to the 1917 crash are not included in newspaper articles, it's difficult to believe he wasn't troubled by the crash.

The Gloversville *Morning Herald* reported that most of those killed in North Branford were women and a few were children. Injuries were so extensive that many of the dead couldn't be immediately identified. The *Hartford Courant* reported that the dead and injured were taken away by automobiles, trucks and wagons. Hundreds of private residents volunteered at the scene, and their personal vehicles became makeshift ambulances. After noting that many of the bodies were horribly mangled, the *Courant* also detailed the Shoreline's other problems: "The Shoreline Electric Railway has been troubled from the beginning." The Shoreline experienced at least two other relatively minor accidents in the same vicinity as the North Branford crash and also was the subject of passenger complaints due to overcrowding and a public utilities probe due to the power outage, according to the article. The system used single-tracked lines, and motormen were expected to memorize the schedules of cars running in the opposite direction to avoid two trolleys meeting in a place where a lack of sidings would prevent a car from pulling aside to allow the other trolley to pass. Given this crude system, it's remarkable accidents weren't even more frequent.

While the Shoreline limped on for a short time after Plant's death, the company was failing quickly. Despite the decision to abandon low-ridership lines such as the one linking the shoreline to Willimantic and South Coventry, the company was forced to declare bankruptcy late in 1919.

LUXURY RESORT AT EASTERN POINT

After Henry Bradley Plant helped tame Florida's swampy, tropical wilderness with his new railroad lines, he decided that the public needed more reasons to ride his rails. His solution was to build a series of exotic, luxurious destination resorts. The crown jewel of this group was the Tampa Bay Hotel, a sprawling complex of fanciful Moorish design replete with every luxury. The hotel opened in 1891, just seven years after the elder Plant brought the first railroad to the remote settlement on the Gulf of Mexico. The five-hundred-room hotel, filled in part with some forty trainloads of furnishings, paintings and objets d'art sent home from Europe by Henry and his second wife, Margaret, also boasted tropical gardens, a golf course, hunting grounds, a ballroom and a heated indoor swimming pool. The hotel hosted some of the country's most notable citizens. Plant marketed his resort to tourists by saying, "Tampa has a climate as bewitchingly balmy as that of Italy, and only one day's ride from the frozen North."

During the Spanish-American War, after shrewd negotiation by Henry Plant to ensure that Tampa was the war's staging ground, the hotel got a huge bump in business when Teddy Roosevelt and his Rough Riders camped on the hotel grounds and the military elite and government officials filled its rooms. Other guests at various times included Clara Barton, Stephen Crane, Richard Harding Davis and Thomas Edison.

Morton Plant apparently learned some valuable lessons about operating resort hotels from his father. After Morton claimed his place as part of Groton, Connecticut's Eastern Point summer colony at the turn of

the twentieth century, the younger Plant soon built his own luxurious establishment. The Griswold Hotel, which opened in 1906, replaced an older and smaller hotel that Plant is said to have found offensively shabby. As important as re-creating the landscape with a contemporary, upscale look was to Plant, the Griswold also fueled many of his other endeavors. The hotel gave some members of the country's monied class a reason to drive automobiles over the new roads he was helping build throughout the region, eat the fresh produce and dairy products he produced at Branford Farms and sail their luxury yachts into the mouth of the Thames River instead of continuing east or north to larger, glitzier resort communities. More workers and members of the era's emerging middle class would also ride Plant's Shoreline trolley to work at or attend events at the hotel.

Morton Plant got his training as a hotelier in his father's resorts. An in-house newsletter for the Tampa Bay Hotel called the *Orange Blossom* and dated March 26, 1898, carried a photograph of Morton and this text: "Son of president Plant and one of the V-Ps of the Plant System is a man of ability and affability and will, some time, assume the entire management of the Plant System with credit to himself and honor to the distinguished name he bears." The newsletter also listed eight Plant system hotels in Florida, along with thirteen railways and nine steamship lines. The hotels all were

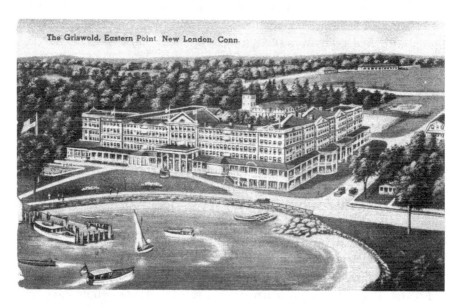

The Griswold Hotel at the Eastern Point summer colony in Groton. Guests were accommodated luxuriously. *Groton Public Library Local History Collection.*

owned by the Plant Investment Company. The Plant transportation empire extended from Halifax, Nova Scotia, and Prince Edward Island, Canada, in the north to Havana, Cuba, and Jamaica in the south.

While Morton may have played a peripheral role at his father's flagship resort, the Tampa Bay Hotel, he is more closely associated with the operations of the Belleview, located northwest of Tampa in what is now Clearwater, Florida. Plant supervised the Belleview's construction, and when the Swiss chalet, shingle-style hotel opened in 1897, it had 145 rooms. One distinct hotel feature was the group of free-standing houses built around it. These houses were occupied by wealthy families from the North who stayed for the entire Florida winter season. The families got to stay rent free for five years and enjoy all the hotel's amenities, including such trendy crazes as bicycle racing.

The Belleview, known as the "White Queen of the Gulf," also was acknowledged for its golf course, developed by Morton. He enjoyed playing the game himself. He was determined to develop a viable course despite the conventional wisdom that Florida's sandy soil would not support the necessary proper grasses. Because Florida's own natural resources didn't allow for great golf, Morton Plant decided to bring the necessary resources to the Gulf. Plant brought trainloads of Indiana topsoil to Florida, and the Belleview course thrived. He was not to be deterred by something like Mother Nature.

Besides the Plant family fortune at his disposal, changing times in the United States also worked in Morton Plant's favor. By 1900, the concept of leisure and vacation time was becoming more important for Americans. While the nation's work ethic and dependence on agriculture had made leisure an unacceptable pursuit from the earliest colonial times, in the decades after the Civil War, the wealthiest Americans became used to escaping the heat, unhealthy air quality and other poor conditions in the growing and industrializing cities for at least some portion of the hottest months. The growing middle class of white-collar workers, managers and Americans with the financial means strove to spend occasional days outside the city to restore their health. End-of-trolley-line amusement parks such as Coney Island, New York, became quite popular. The seashore, then as now, was among the most sought-after destinations. In southeastern Connecticut, where Plant held sway, small summer colonies were growing near the mouth of the Thames River, although true vacations and leisurely weeks spent lolling at the beach remained the stuff of dreams for most residents of the region. Still, a collection of

Gothic and Arts and Crafts–style cottages created New London's Pequot Colony on the west bank of the Thames near Long Island Sound, while another group of initially modest cottages, then more grandiose summer retreats, created the summer colony of Eastern Point in Groton on the east side of the Thames.

Morton Plant bought property at Eastern Point the same year his father died in 1899. Before building Branford House, he built his first Eastern Point summer home at 15 Shore Avenue—a three-story, shingle-style cottage with two chimneys, nine bedrooms and a wide-open porch that wrapped around the graceful stone arches of the façade on the shoreline side of the house. Within a few years, his Branford House mansion located on Avery Point, just south of his original property, was completed. Plant's dominance in the Eastern Point colony didn't stop there. Besides buying parcel after parcel on which to establish and grow his farms, he also built the Griswold, which soon became not only a favorite society destination but also a place where locals could find steady and decently lucrative employment and the rest of the public could take a peek into a grand lifestyle.

As with most of Plant's pursuits, his development of the Griswold became the focus of local residents' attention. The *New York Times* reported that Plant purchased the hotel in June 1905. When the older, smaller hotel closed for the season, Plant immediately began the task of demolishing it and building the new, grander hotel that would dominate on the east bank of the mouth of the Thames River for many decades and accommodate some of the wealthiest families of the era, as well as host many special events and banquets. In September 1916, it even hosted the American-Mexican Joint Commission's peace conference, which brought officials from both countries together to try to work out problems at the U.S.-Mexico border stemming from the Mexican Revolution. In March 1916, Pancho Villa and his rebel followers attacked Columbus, New Mexico, and U.S. troops led by General John J. Pershing then embarked on an expedition into northern Mexico, causing tensions between the two nations.

In a January 1986 column published in *The Day*, Groton's longtime local history expert, Carol Kimball, wrote that 140 men working for a contractor named Whipple of Norwich began to demolish the hotel in September 1905. By December, some 125 carpenters were busy constructing a grander replacement. The work was completed on the new four-hundred-room structure in just seven and a half months, according to local newspaper reports. When the gleaming new property opened for the season, a crowd of 400 onlookers gathered as Plant's son, Henry, raised the flag at the hotel.

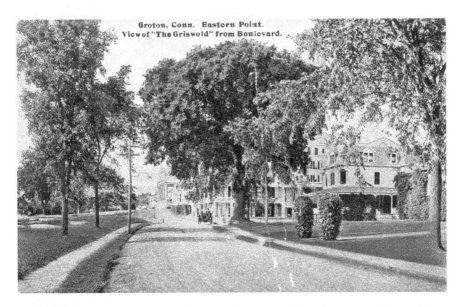

A view of the Griswold and nearby Eastern Point houses. *Groton Public Library Local History Collection.*

It was evident Plant wanted the hotel to serve as a stop for the increasingly popular pastime of automobile cruising. He was fascinated with automobiles and wanted to encourage others who shared his fancy to come to the Griswold. In 1900, just 8,000 automobiles were registered in the country, but only ten years later, that number had skyrocketed to more than 458,000. Plant was only too happy to accommodate this growing trend.

On January 20, 1909, the *New York Times* reported that Plant was among those attending Society Day at the ninth annual auto show in Madison Square Garden. He was reported to order the first American-made addition to his garage, already full of several cars of foreign vintage. His choice was a Corbin 30, a touring car made by a short-lived New Britain, Connecticut manufacturer. The car cost about $2,600, which in 2016 dollars would be more than $65,000. Plant continued to buy American cars. The June 1915 Connecticut Motor Vehicle register listed Plant as the owner of five luxury vehicles: two 1913 Stevens-Duryeas manufactured in Chicopee, Massachusetts; a 1914 Locomobile made in Bridgeport; and 1913 and 1914 Cranes, manufactured in Bayonne, New Jersey.

At a time when more and more Americans were buying cars, good roads were still being developed. Plant also helped in this regard. The April 5, 1912 edition of the *Norwich Bulletin* reported that Plant offered to pay half the cost

of building a new highway between the village of Poquonnock, located just east of Plant's estate, and the bustling fishing and shipbuilding village of Mystic, about four miles farther east. Plant also agreed to contribute half of the $30,000 cost to build three miles of highway in the Golden Spur area of Waterford. That old road was reported by the local press to be one of the worst stretches in the New London area.

A tourist booklet promoting the Griswold touted the fine quality of the roads in the region: "Automobile tourists may reach The Griswold via the New York and Boston shore route. The famous state roads on this route and in the vicinity are unsurpassed. Modern garage facilities." The brochure included several photographs with cars in front of and near the hotel. "An almost constant stream of automobilists is seen passing into the hotel court entrance at all hours of the day," the *Hartford Courant* reported on August 13, 1910, about the Griswold's popularity with automobile owners. The existence of so many wealthy families' automobiles in the area also provided opportunity for locals to work as chauffeurs, valets and drivers, as well as automobile mechanics. The hotel had an on-site garage.

While it's difficult to determine exactly how many southeastern Connecticut residents secured permanent positions at the Griswold, or because of it and the existence of the summer colony, it is certain that jobs were many, varied and available. Launches met guests at the New London train station, and pilots were needed for these. The usual range of hotel employees, porters, front desk clerks, housekeepers, groundskeepers, cooks and waiters worked during the busy Griswold season, which generally extended from mid-June until early September. The mahogany in each guest room had to be kept gleaming, guests' shoes needed shining and ladies' elaborate wardrobes of the day required laundering, ironing and mending.

In addition, professional musicians played at the hotel each morning and at dances each evening. Many workers were employed to care for the livestock and cultivate the vegetables and fruit at Branford Farms, through which guests also regularly toured. An advertisement for the Griswold published in a 1911 edition of *Field and Stream* magazine promoted the hotel in this manner: "Finest seashore resort in America; sailing, bathing, automobiling, driving, tennis, golf, dancing. Long distance telephone in every room; new grill, new boat service, dairy and garden products from our own farms—Branford House Farms." There also was a resident physician, a newsstand, a Western Union office, a manicure and hairdressing salon, docking facilities, four tennis courts, a saltwater pool and a dining room that accommodated 1,360 guests at a

time. A constable was hired to ensure that non-guests didn't sneak into facilities such as the golf course.

It was common for many of the staffers to travel between the Belleview and the Griswold, working in both places in their respective seasons. The Belleview was open from January through April. Both hotels also required preparation in advance of their seasonal openings.

While the Groton hotel outlived its owner by several decades, by the end of its life in the 1960s, the cavernous, empty structure had become an eyesore and a favorite target for vandals. The hotel, which served its last guest in 1967, was purchased by the pharmaceutical giant Pfizer Inc. for $395,000 and demolished in 1969. Much of the former Griswold site remains an open lot. Pfizer, which has a large facility in Groton, also purchased many of the former Eastern Point summer colony cottages and houses.

While the hotel is now but a memory, another of Plant's contributions to the Eastern Point community—his golf course—continues to thrive under municipal ownership. It has been the municipally run Shennecossett Golf Club since 1969. As he had at the Belleview, Plant took advantage of the growing interest in golf at the turn of the twentieth century and developed a top-notch golf club for the Griswold resort. Golf actually predated Plant's formal arrival at Eastern Point. Thomas Avery, the farmer who owned much of Eastern Point before Plant began buying property there, developed a four-hole course with a clubhouse. Plant, building on his expertise in developing the Belleview golf course, expanded the course to nine holes in 1906 after purchasing the property. By 1914, Plant had built a full eighteen-hole course and upgraded it to championship quality. The holes were laid out by Donald J. Ross, one of the era's most revered golf architects. Ross, who was of Scottish origin, also designed the Belleview course for Plant.

Golf soon became popular with Plant's Griswold guests, including members of the Belden, Cushman, Fleischmann and Heublein families, wealthy industrialists from Hartford, Baltimore, New York and Philadelphia. In 1914, it cost one dollar per day to play at the golf club and twenty dollars for the July–August season. While plenty of historic photographs exist of the Griswold's high society guests out on the links, it is rarer to get insight into the experience of a working person at the golf club. A bit of that insight is provided by James J. Delmore of New London in an undated typed report recounting his experience as a boy caddying at the course in 1916. The report is now in the Groton Public Library's local history collection.

After his older brother consented to his pleas to accompany him to the course to pick up caddy jobs, Delmore recalled his mother giving him nine

cents for the day. A nickel would buy a Coke, and the other four cents (or was it six cents—he couldn't recall) would pay for the round-trip transportation on the ferry that crossed the Thames between New London and Groton. The huge paddle-wheel ferry took passengers, horses and wagons and the occasional automobile. The ride took about eight minutes each way, he recalled. Once in Groton, the brothers had to find a ride to Eastern Point or walk the more than two miles to the golf course. He remembered walking down the cement road Plant built for his hotel and golf course, which was the only paved road in the area at the time. Delmore also recalled marveling at the huge freighters under construction at the Groton Iron Works, located in the vicinity now occupied by Pfizer.

Once at the golf course, Delmore joined the other boys waiting to work as caddies. Because most of the boys were older and bigger, Delmore endured some taunting and joking about looking like a kindergartener. But the goal for all the boys—some 150 on a weekend—was to earn money. Delmore wrote that the caddy fee was fifty cents for eighteen holes, thirty-five cents for nine holes and twenty-five cents an hour to shag balls on the pro fairway practice area. The best caddies earned about a dollar a day, as they could caddy two full rounds.

After being the final boy left alone in the caddy yard, Delmore said the caddy master finally assigned him a number, and at about 11:00 a.m., he got

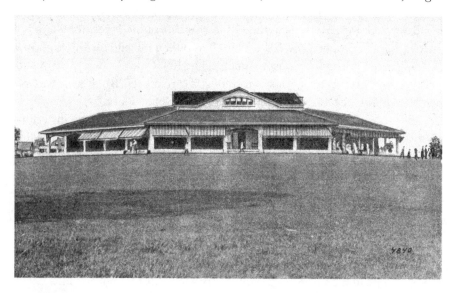

The Shennecossett Golf Club's clubhouse. Originally built as a Griswold Hotel amenity, the course is now owned by the Town of Groton. *Groton Public Library Local History Collection.*

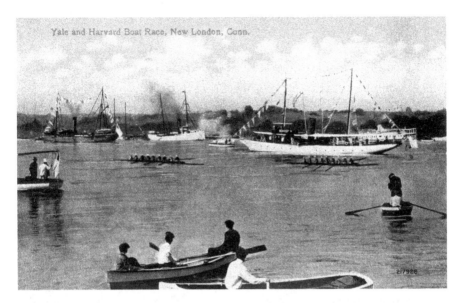

The annual Thames River Yale-Harvard boat race was wildly popular in Plant's time. He attended, brought hotel guests and friends there and supported the event financially. *Groton Public Library Local History Collection.*

The Belleview in Clearwater, Florida, was another luxury hotel overseen by Plant. The facility shared staff with the Griswold. *Plant Family Collection.*

his first chance at caddying a nine-hole round. He was assigned to a golfer who could not play very well, and Delmore recalled spending a lot of time searching the rough for the duffer's ball. After nine holes, however, the golfer paid Delmore thirty-five cents, which was the fee for a more experienced caddy. Because Delmore was a novice, a fee of just a quarter would have been acceptable.

"I was tired but happy and couldn't wait to get to the Caddie pen to tell my brother about my first caddie experience," Delmore wrote. "He seemed pleased and had my lunch waiting for me. After a long while he said I did very good for my first time and that I would improve as I went along." After lunch, the brothers again took their spots in the caddy pool, and his brother's number soon was called. Delmore again waited until he was the only caddy left in the pool. The assistant pro asked Delmore to shag balls at the practice tee.

"In those days most of the top professionals were Scotch [Scots] and Shennecossett Club had one of the best, Alex Smith, who twice won the U.S. Open," Delmore wrote. "He was perhaps one of the best teachers of the game at the time. He gave lessons five days a week from 8 a.m. in the morning until 12 noon and from 12:30 p.m. to 5:30 p.m. and had a waiting list two or three weeks ahead." Delmore was assisting Smith's assistant, Sammy Belfore.

"The lesson took about one half hour and Sammy gave me 15 cents," Delmore wrote. "I waited around for my brother to finish his caddie job and we were lucky to get a ride to the ferry slip. We arrived home about 6 o'clock and I was the proudest caddie in the world as I told of my caddie experiences around the kitchen table."

A Sportsmen's Retreat

G uests of Henry Bradley Plant's Tampa Bay Hotel had no need to stray far beyond the lavishly cultivated resort gardens and broad hotel verandas to find a wild and untamed landscape. This made for a perfect setting for the gentleman sportsmen so common among the social elites who frequented the hotel. The bay itself, along with the Hillsborough River flowing in front of the hotel, teemed with enough fish to overwhelm guests out for a day of angling. For hunters, the tangle of wetlands and forest a short distance northwest of the hotel grounds overflowed with game.

With a professional guide leading them, hotel guests on hunting excursions returned with an astounding amount of game, numbers that seem obscene by contemporary standards. "In five days their hunting parties bagged 321 quail, 147 snipe, 82 ducks, 42 doves, ten plover, one rabbit, one deer and an uncounted assortment of squirrels, sand hill cranes, pink curlews, and white and blue egrets," Kelly Reynolds wrote in his book *Henry Plant—Pioneer Empire Builder* in recounting specific Tampa Bay Hotel hunting expeditions. One guest even achieved this one-day, single-man bird kill: 283 snipe and plover.

Morton Plant, who would have witnessed such hunting bounties, grew accustomed to such guest amenities at the Tampa Bay Hotel and his father's other resorts. He was also busy expanding his own influence and strove to offer his friends and Griswold Hotel guests as many similar experiences as possible. Connecticut in the early twentieth century, however, could not match Florida in terms of open space or wilderness overflowing with

wildlife. In fact, the very type of unchecked, unregulated hunting common during much of the United States' history and practiced by Tampa Bay Hotel guests contributed to the decline of natural resources in many places, including Connecticut. Ironically, while it was wealthy Americans who most enjoyed bagging game during hunting expeditions, these same people were integral to rebuilding those resources because they understood that without land conservation, there could be no hunting grounds for sportsmen.

When European settlers first came to what would become the United States, they killed game to survive. They ate the meat and used the fur and hides for clothing. So-called vermin, animals such as foxes and weasels that killed domestic livestock, also were fair game for farmers struggling to protect their crops against the elements. Homes were heated by wood, necessitating cutting down huge numbers of trees. Forests also made way for farmers' fields and pastures. Connecticut was largely clear-cut by the mid-1800s.

During the post–Industrial Revolution, and as the financial means of a certain segment of American society grew, hunting for pure sport also surged in popularity. As long as America's wilderness appeared limitless, such unfettered killing akin to slaughter seemed inconsequential. By the second half of the nineteenth century, however, many Americans could see that a lack of regulation and protection of natural resources was taking a toll. Vast areas of natural habitat were disappearing. Industrial pollution and landscape changes such as dam building and wetlands filling were depleting and eliminating species. In Connecticut, evidence of the diminution of wildlife began much earlier. The last wolf was shot in the state in 1742. By 1813, wild turkeys were gone, and by 1842, beavers were no longer found within the state's borders. In 1866, Connecticut created a state Fisheries Commission and three years later passed a law to appoint the first law enforcement officers charged with the protection of wildlife. In 1895, the Connecticut Board of Fisheries and Game was established.

Then came the Gilded Age and its sportsmen, who helped restore wild birds, deer, fish and other game. Their motivation was twofold. They sought to provide fertile sporting grounds for themselves and their friends but also recognized that encroaching development had to be impeded in order to achieve this. Morton Plant was among those in Connecticut who contributed to improving the health of the state's game, but his efforts began, at least in part, with his desire to offer his friends and Griswold Hotel guests the same luxuries with which he was familiar.

A friend's death spurred Plant's conservation efforts. In January 1906, Robert Gallaudet Erwin of Hartford—a friend of Plant's who served first as

general counsel and then vice-president and president of the Plant System of railroads and who also was active in the Plant Investment Company that owned and operated the vast system of Plant hotels, railways and steamship lines—collapsed and died of a heart attack while tramping through his private game preserve at Old Saybrook. Establishing game preserves to help boost the wildlife numbers in the state was one of Erwin's dreams. He frequently talked to Plant about his vision. Shortly after his friend's death, Plant bought a huge tract of land formerly owned by Erwin in East Lyme, adding to it with other large parcels of woodlands, meadow and river.

"As soon as I could get around to it, having the desire to carry out the wishes of my friend, through another friend, Arthur Shipman of Hartford, who was one of the trustees of Mr. Erwin's estate, I obtained title to such of the property as he had purchased, and immediately following this, secured some 1,800 to 2,000 more acres, whereupon I took steps towards the raising of Hungarian partridges and English pheasants," he wrote in a statement published in the *Hartford Courant* on September 20, 1914, just after Plant arrived at an agreement to give the State of Connecticut a ten-year lease to the East Lyme property for use as a game preserve. Plant ended up owning more than 3,000 acres in the northern part of East Lyme. A small portion of the parcel also extended into the towns of Lyme and Old Lyme. The expanse was located only about fifteen miles west of New London, but with few good roads at the time, it was remote and wild, especially for shoreline Connecticut.

Plant set about making the preserve more accessible by paying half the cost to build a new highway through the site and then east to New London. Plant's Shoreline Electric Railway also ran through the property. Shortly after he acquired the land, Plant hired architect Dudley St. Clair Donnelly to help design a craftsman-style bungalow that was less cozy than sprawling. It had more than a dozen rooms, two huge precast concrete fireplaces and five guest bedrooms, plus room for a full-time caretaker and a master bedroom suite. On February 18, 1908, the *Hartford Courant* reported that work was to begin that week to construct the bungalow, which would be known as the Morton F. Plant Hunting Lodge.

Plant also hired a contractor to design and build a dam on the Four Mile River, along with trout ponds. He acquired several species of game birds and built elaborate bird pens and kennels for hunting dogs. Workers lived on site to care for the animals and ensure the breeding and propagation of the game birds that included pheasants, quail, turkeys, grouse, woodcock and

ducks. Plant called the property Plantford Farm, reserving one section of it as a true farm where he raised and kept pigs and poultry.

Plant and his colleagues had only a few years to enjoy the property, however. In the 1914 statement published in the *Hartford Courant*, Plant wrote, "A few years ago, it became so necessary for me to pass much of the time in the South and in Europe, that to an extent, I gave up the raising of birds as extensively as I did before." Plant's loss was the state's gain. At this time, the Board of Fisheries and Game was searching for appropriate game preserves to begin the long task of replenishing the state's wildlife. A friend connected to the commission approached Plant, and Plant agreed to a ten-year lease.

"I was pleased to turn over such part of the property as was not under cultivation and am certain that the same will be of benefit to the citizens of the state of Connecticut, as the commission will have experts to propagate and continue the raising of birds," Plant wrote in the statement published in the *Courant*. He estimated the amount of land at the site to be upward of 5,000 acres. In addition, he donated a 350-acre portion of the parcel to the Sheffield Scientific School, a now-defunct school that was part of Yale College. The land would allow Yale to build a summer camp for the study of engineering, Plant wrote.

By the time Plant and the state agreed on the lease, the preserve was somewhat neglected; evidence of its grand not-so-distant past remained, however, and the cultivated portion of the farm continued to thrive. The *Hartford Courant* reporter wrote in the 1914 article, "At present, a casual visitor would find but little at Plantford Farm, which is the name which Mr. Plant has given the model farm, established on the same property. While the farmwork [*sic*] has been prospering and the piggery on the hill where are raised some of Mr. Plant's choicest Berkshire litters is very active, the game preserve is deserted. In the brooding houses, a few ancient hens peck disconsolately around." The article continued, "There are very few game birds on the preserve now. Two years ago, when Commodore Plant's keepers were actively engaged, quail and pheasants flushed from every clump of weeds. A ten acre patch of corn near the farmhouse was so filled with the birds that the harvesters were seriously hampered in their work."

Still, the preserve was a lovely landscape. "The preserve is a pleasant hour's ride from New London on one of the swift cars of Shore Line Electric Railway," the *Courant* reporter wrote. "On the right side of the road it first comes into view as a clump of neat appearing buildings lying slightly back from the road in the midst of shorn fields, while behind rise densely wooded hills of dark green foliage. They will present a glorious appearance after the

first frost this fall. Descending from the trolley upon the rounded, smooth surface of one of the Plant highways, one turns into a drive which has the appearance of a made road." The reporter went on to describe the extensive and lavish (though by that time empty) dog kennels, complete with a kitchen in which to cook the dogs' meals and a bathtub with hot running water in which the canines were bathed.

The 1913–14 report of the State Board of Fisheries and Game noted that the preserve was undergoing complete renovations. "Many hundred vermin have been trapped," the report said. "We have shipped about 50 pheasant (which are all the place can take care of at present), about a dozen hens, purchased about 100 steel traps, and feed for the ducks. Breeding boxes for wild ducks are to be made."

The *Courant* article made clear that the state planned to ensure, at least temporarily, that the preserve was not a hunting ground. State officials called it an "isle of safety" for the wild birds being bred there. Except for the so-called vermin that would otherwise prey on the birds and efforts to eliminate two-legged poachers from sneaking uninvited onto the property, the state would ensure the birds lived unmolested. "The proposition at the East Lyme preserve will be as it has been at the state game preserve at Madison, to remove vermin from the preserve, allow the birds to increase unharmed, the overflow into the territory surrounding the preserve forming the foundation of excellent shooting during the open season," the *Courant* reported.

With the agreement between the state and Plant, the land that was now referred to as the Morton F. Plant Game Preserve played an important role in each of two diverging schools of thought at the time. Preservationists wanted natural resources to be protected in perpetuity, while conservationists argued that natural resources should be bolstered for future use, including sporting. In the end, however, neither side of this argument had a very long history on this particular parcel of land, although Plant's actions did play a long-term role in ensuring that the large tract of land near the Connecticut shoreline remained undeveloped and an important wildlife habitat.

Plant died just four years into the ten-year lease deal with the state. The East Lyme game preserve was divided into several parcels by his estate in an effort to help settle an Internal Revenue Service claim that Plant improperly deducted his farming losses when paying income taxes. The estate ultimately won the case, but not until 1922.

In 1920, *The Day* of New London reported that Thomas Frusher, chief chemist with the United States Worsted Company of New York City, who was living in the Mohican Hotel in New London, bought 1,800 acres that

included the farm, equipment and buildings for $50,000. One parcel that contains the former hunting lodge continues to be privately owned. The lodge was admitted to the National Register of Historic Places in 1988. By 1931, another large tract that was formerly Plant's was serving as the Stone's Ranch Military Reservation and is the site of National Guard training exercises. It was named for entertainer Frederick Andrew Stone, who had bought the parcel from Morton's son, Henry, in 1925.

A College for Women

O n a Saturday afternoon in 1911, Morton Plant was stuck in a conference room at the New York, New Haven and Hartford Railroad offices in New Haven. It was early June, and for Plant, that meant it was baseball season. He grew impatient as he thought about his team, the Planters, scheduled to play that day. Discussion dragged at this second meeting of the Board of Trustees of the proposed New London women's college.

It's not that Plant was not an enthusiastic supporter of the campaign to establish the college in New London. Some six thousand southeastern Connecticut residents and business and political leaders had stepped forward with donations that were tracked on a giant clock displayed on the downtown office of *The Day* newspaper. The city's fundraising efforts exceeded the state's required financial commitment by $35,000. Plant himself donated $25,000, agreed to serve as a college trustee and now was chairing that group. The Allyn, Palmer and Bolles families donated land, and the city appropriated $50,000 to buy enough adjacent property to result in a 340-acre campus, a grassy and scenic if somewhat forlorn and lonely tract overlooking the Thames River north of the city's downtown.

Still, all these efforts were not enough to ensure that the college could actually be successfully established, and the trustees struggled to raise enough money for an endowment, including money to pay ongoing expenses. Plant, exasperated by the conversation at the 1911 meeting and so worried he'd miss seeing his team play, made a bold offer: would $1 million put the trustees'

minds at ease? Indeed it would—the Connecticut College for Women was finally a reality.

Morton Plant was revered in southeastern Connecticut, and his contributions to the region were many. It could be argued that this pledge of $1 million, however, had the greatest and longest-lasting impact of any action he took for shoreline Connecticut—an impact that extended in perpetuity. Not only did the establishment of what was originally called Thames College (but changed at Plant's urging to Connecticut College for Women) provide the opportunity for young women to pursue a four-year college degree in the state, but it also gave that opportunity to generations of young women and, much later, to young men after the college became coeducational in 1969.

Between 1890 and 1910, the number of U.S. women enrolled in college increased nearly 800 percent, according to information in "Chapters in the History of Connecticut College during the First Three Administrations, 1911 to 1942," compiled by Irene Nye in 1943. Four of the top East Coast colleges each had four hundred more female applicants than they could accommodate. Graduating from high school, let alone college, was still far from a certainty for Americans in 1910. During the last half of the nineteenth century, roughly half of all U.S. five- to nineteen-year-olds were enrolled in school. In 1910, only 13 percent of the U.S. population held a college degree. The number of women with college degrees was far less than 1 percent of the overall population.

Around the turn of the twentieth century, however, a fairly steady and steep upward trajectory in the number of women seeking higher education began, especially among those of higher socioeconomic status. At the same time, the opportunity for women to pursue a four-year degree in Connecticut actually disappeared. In 1909, Wesleyan University in Middletown decided to no longer admit women. While women still could pursue what at the time was considered vocational training at a teacher's college or the state agricultural college, the ability to earn a baccalaureate degree in state was gone.

Wesleyan's decision led a group of female members of the Hartford College Club to come together in 1910. Led by Wesleyan alumna Elizabeth Wright, the women sought to restore the four-year college degree opportunity for women. Their efforts led to a lively competition among some two dozen Connecticut communities clamoring to host a new college for women within their borders. New London ultimately won the privilege, but even after the state accepted the Whaling City as the most likely site, the new college was far from a certainty. That is, until Morton Plant's donation.

"With the unconditional pledge of $1,000,000 for the establishment of a college for women at New London the erection of that institution of learning is practically assured," the *Hartford Courant* reported on June 5, 1911. "That the gift was without restrictions, save the income is to be used to pay the running expenses of the college was announced in a letter made public by Mr. Plant last night."

The Day of New London reported on June 13, 1911, "He has now come to the agreeable conclusion that the best way to set the college on its feet is to give it a million outright—'to start the ball rolling' is his modest way of putting it. Mr. Plant's action is both generous and wise. It will enable the trustees to go ahead at once with their plans, instead of delaying to collect the requisite money in an arduous and fatiguing campaign." *The Day* also noted, "It is worthy of note that the Plant million is to be used for running expenses. Very often college benefactors give money for the erection of buildings that will perpetuate their memory and omit to provide for the maintenance of these."

Plant's endowment allowed him to get to his baseball game and provided the chance for generations of young women to secure a four-year college degree. But the unusual story of the $1 million donation doesn't end with the Board of Trustees meeting. Some thirty years later, William J. Farnan, one of Plant's chauffeurs, wrote a letter that is now in the Connecticut College archives about the nerve-inducing trip on which he took his boss to a Hartford bank to pick up the cash Plant pledged. With very few well-paved roads, the drive was far from a leisurely jaunt. Plant left the Hartford bank carrying the $1 million in cash in a bag, and the duo began the return trek to the shoreline. On the way, however, Plant decided to stop in Old Saybrook for a meal. Farnan's letter recalled how he nervously waited outside the restaurant with the car—and the cash—as his boss ate a rather long and expansive meal.

As New London bankers worried over Plant's overdue arrival, residents lined the sidewalks, craning their necks in anticipation of Plant's automobile coming into view. When Farnan finally pulled the car up to the sidewalk in front of the New London bank, the throngs were cheering.

While Morton Plant gets most of the credit from posterity for his role in establishing Connecticut College, his wife, Nellie, also deserves accolades. She studied at the Sorbonne in Paris and no doubt held women's education in high esteem. Nellie's daughter-in-law, Amy Plant, wrote a letter on May 15, 1931, also held in the Connecticut College archives. The letter noted that Nellie was the key to the Plants' involvement in the college's founding. Nellie

also served on the college's building committee, working with the architects to design the buildings and furnishings, with the façades emulating the style of Branford House.

Besides the endowment money and the amount donated to the original New London college fundraising campaign, the Plants also gave $60,000 for each of two college dormitories: Plant and Blackstone Halls, named in honor of Morton Plant's parents.

While the establishment of Connecticut College was a milestone for all women in the state, the school at first served primarily young women from higher socioeconomic echelons. An undated letter in the New London County Historical Society archives to Plant from Colin S. Buell, principal of Williams Memorial Institute and one of the early supporters of the college effort, stated it bluntly enough, for example: "I hope you will not insist that all Connecticut girls shall have free tuition at the college. Too great freedom cheapens an institution, and in my judgment a few scholarships which the girls would have to earn in some manner, would tend to raise the tone of the college." The letter indicates that the Plants may have had a different view on admissions to the college.

The reality of the early years at the college is noted in a thesis written in 2011 by Lilah Raptopoulos titled "A Partial History of Connecticut College": "They lived in textured granite, Collegiate College dorms traditional of New England colleges, with slanted roofs, stone chimneys, balconies and heavy oak doors. These dorms were cozy, safe and looked

The site that would become Connecticut College was picturesque but somewhat remote and forlorn. *Linda Lear Center for Special Collections and Archives, Connecticut College.*

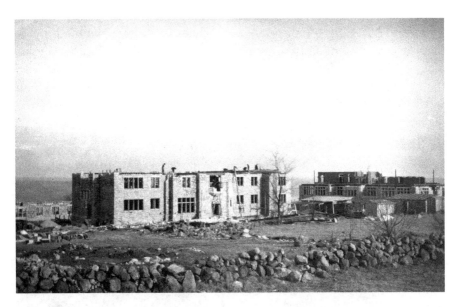

The original Connecticut College quad under construction. *Linda Lear Center for Special Collections and Archives, Connecticut College.*

like home. The girls had a staff of four black maids and butlers who changed their sheets and prepared weekly teas in their common rooms." Raptopoulos also quoted from the writings of Julia Warner Comstock, an early alumna: "Inconveniences were temporary and 'luxuries' permanent. Each campus student found her Plant or Blackstone dormitory room completely furnished not only with bed, dresser, desk and chair, but with rugs, cretonne drapes with matching couch cover, linens and bedding and desk lamp. There was running water in every room and all but two or three were single rooms."

Despite this, the first students certainly endured some inconveniences, if not hardships. Raptopoulos wrote about the recollections of Comstock, who was a member of the college's first graduating class. "Because there was no grass, wooden planks made paths over the rough, muddy grounds of the Quad," Comstock recalled, adding that the smell of paint and fresh plaster permeated the air and meals were eaten to the rhythm of carpenters' hammers.

A *Hartford Courant* reporter on August 1, 1915, seemed incredulous after touring the campus that classes would commence by September 27. "High up on the west bank of the Thames River a little north of the city of New London, three handsome stone buildings of the Connecticut College for

Women are nearing completion. One reaches them from the roadway by bumpy, hazardous progress over miniature hills and valleys of dirt and stone and wonders how the $3,000 to be devoted to that purpose can ever make the brush grown hillocky waste into a smooth campus to correspond with the Tudor buildings it surrounds." The reporter also was not so enamored of those buildings, writing, "There is a uniformity, a grey sameness about the buildings at present that is a little depressing."

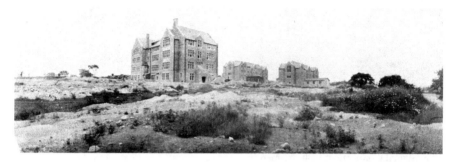

The appearance of Connecticut College was somewhat bleak at first, causing a reporter in 1915 to call the "gray sameness" of the buildings depressing. *Linda Lear Center for Special Collections and Archives, Connecticut College.*

The interior of Blackstone Hall, one of two dormitories for which Morton Plant paid. The dormitories were fairly luxurious and even included maid service. *Linda Lear Center for Special Collection and Archives, Connecticut College.*

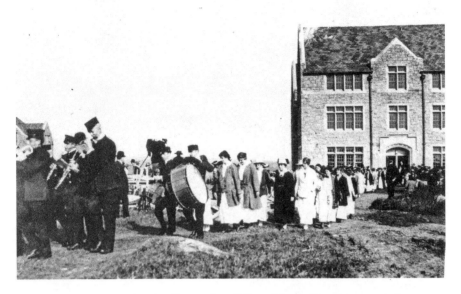

The opening day processional at Connecticut College. Morton Plant was awarded an honorary doctoral degree during ceremonies that day. *Linda Lear Center for Special Collections and Archives, Connecticut College.*

In less than two months, however, the college opened, and a formal ceremony was conducted on October 9, 1915. Prominent educators from throughout the country attended, along with residents of the city. Ceremonies included an academic procession, greetings and congratulations sent by President Woodrow Wilson, a luncheon, speeches by legislators and an invocation. Morton Plant was a focus of the day's festivities. The college bestowed on him an honorary doctor of laws degree.

"It is given to us all the chance to do good," Connecticut College president Frederick Sykes was reported as saying in an article in *The Day* of New London, as he conferred the degree to Plant. "The little unremembered acts of kindness and love that are the best portion of a good man's life. But the man who can do public good is rare. To found a college—an institution that is a central power house for human betterment—diffusing light and guidance and trained power at the high points of social organization—such public beneficence is indeed rare. Few have the means, therefore fewer the appreciation of opportunity, still fewer the will to do."

Ironically, Plant already was at odds with Sykes by this point. Plant ended his term as chairman of the college trustees in 1914, although he continued

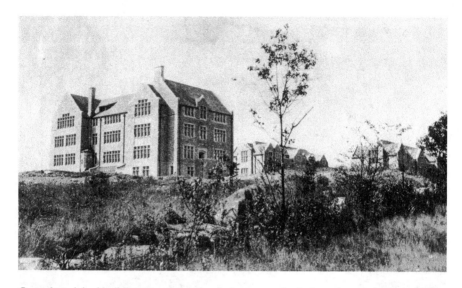

Once the original buildings were completed, the campus looked much more inviting. *Linda Lear Center for Special Collections and Archives, Connecticut College.*

to serve on the board. Following a rather messy and public dispute between the trustees and Sykes, the Canadian-born former Columbia University English professor was fired from his position as Connecticut College president in 1917. Sykes held a rather enlightened and progressive view of the potential of women in American society, seeing them as integral to helping solve the many ills plaguing the growing nation, whose cities were teeming with immigrants and the associated problems of poverty. The students and faculty remained loyal to him throughout his dispute with the trustees, and while the origins of the dispute are not totally clear, they seem to have begun when Sykes refused to pay what he thought was an unfair price for coal to heat the college buildings, angering some of the business owners who served as trustees.

The dispute threatened the existence of the young college, but despite the strain, Connecticut College soldiered on after Sykes's removal. Plant, while he sat squarely with the business leaders who sought Sykes's ouster, continued to support the college. Plant left another $250,000 to the college in his will, boosting his total monetary contributions to the school to nearly $2 million.

GIFTS FOR THE COMMUNITY

I n May 1911, just weeks before the HMS *Titanic* launched and the first running of a five-hundred-mile automobile race that later would be called the Indianapolis 500, Morton F. Plant took a more relaxing car ride through the eastern Connecticut countryside. He traveled some twenty-five miles inland from his Avery Point estate through a tiny village he hadn't before visited. In Newent, a part of the town of Lisbon, he was struck by the poor condition of the iconic New England congregational church there.

The church's classic Greek Revival architecture was marred by badly peeling and chipping paint. Plant knocked on the door of a nearby house and inquired of the whereabouts of the minister. When the woman who answered the door told Plant that the church was so small it had no resident minister, Plant gave her his card and told her to convey a message to the pastor when he came to town for services: have the church painted and send Plant the bill.

Plant's larger and splashier endeavors, such as building Branford House and endowing Connecticut College, had more significant impact, but it was the many smaller contributions, such as having a humble country church painted, that helped forever endear him to the community and brought Plant an extremely broad base of respect and admiration. Elizabeth Wright, the driving force behind Connecticut College's establishment, who came to know Plant through his connections to the college effort, wrote that Plant had a pleasing personality, a "gracious manner, especially with people who were less fortunate," and a "quiet,

rare humor." He seemed especially drawn to children and always had a smile for them, she wrote.

Perhaps it was this empathy for the common man that drew Plant to regularly provide small contributions to many churches besides the one in Newent. While his own religious beliefs are not clear, there is much evidence that Plant had a soft spot for churches and their financial struggles. He also provided larger contributions. On November 3, 1914, the *Norwich Bulletin* reported, for example, that Plant donated a new organ being dedicated at St. James Episcopal in New London. Plant gave the organ in memory of his late wife, Nellie.

Although Catholics still were viewed with suspicion, if not downright hostility, by many Americans at the time, Plant, perhaps because his stepmother was Irish Catholic, also demonstrated a deep respect for the religion practiced by many of his employees. Many skilled Italian stonemasons and woodcarvers helped build Branford House, and other Catholics also were employed both at the estate and the Griswold Hotel. In the early 1900s, many Catholics in Groton rode the ferry to New London on Sundays to attend mass at St. Mary Star of the Sea. By 1907, masses were conducted at a variety of temporary Groton locations, including Eastern Point School, another building that is now the Sub Vets hall on School Street and even at Plant's Griswold Hotel. According to a written history of Groton's Sacred Heart Parish, in 1911 Plant donated land on Eastern Point Road, along with enough money to build a rectory and church. The cornerstone of the new church was laid on July 14, 1912, and *The Day* of New London reported that both Plant and his wife attended the event. The church was completed and dedicated on January 19, 1913. Decades later, in 1961, the site, along with the church and rectory, was sold to Electric Boat, the nearby submarine shipyard, and the parish moved to land off Mitchell Street in Groton. The original site is now an EB parking garage.

In addition to helping churches, Plant often assisted the Town of Groton, at one point paying off its $25,000 debt. He contributed to road projects throughout the region, shored up many local businesses by purchasing their stocks or providing them with loans and favored hospitals with his beneficence. He owned newspapers at least briefly in both New London and Boston and regularly supported the annual Yale-Harvard regatta, and in 1906, the *Fort Worth Star-Telegram* reported that he gave the Yale crew land and a house at Gales Ferry, fronting the Thames River, where the annual races attracted thousands of spectators, some of whom watched the festivities from railroad cars on tracks that ran parallel to the river. Although the race may have lost

some of its luster in later years, the Yale-Harvard rowing regatta is touted as the nation's oldest collegiate competition, having begun in 1852 on New Hampshire's Lake Winnipesaukee before relocating in 1878 to southeastern Connecticut, where it remains.

Plant also built a five-story office building in New London and held a mortgage on New London's Mohican Hotel, considered at the time one of the city's finest lodgings. He provided money to build a dormitory at the Pomfret School, where his son, Henry, was a student, donated $10,000 and the use of the Watson House at Eastern Point to the U.S. Navy as a hospital during World War I and served on a long list of boards ranging from the state park commission to the Nathan Hale Council of the Sons of the American Revolution.

In Groton, Plant provided the money to build a new town hall in the Poquonnock section of town, not far from Branford Farms. Previously, the town conducted meetings at a ramshackle townhouse at the top of Fort Hill, and the town clerk kept all official municipal documents in a small building erected at his home specifically for that purpose. In 1907, Plant told town officials that he'd pay to build the town hall after they found a suitable piece of land.

Plant, fresh off a cruise aboard his yacht *Venetia*, was fêted at the building's dedication in September 1908. Groton declared a holiday, and extra trolleys were put into service to carry the throngs to the event. Plant was cheered and presented with a silver loving cup. Not one to enjoy the public spotlight, Plant made only brief remarks, saying he hoped the hall would be "a center for meetings and lectures, interesting and profitable and that it will aid in enabling everyone to become better citizens—the best of citizens," *The Day* of New London reported on September 18, 1908. Also during the ceremony, U.S. Senator Frank Brandegee said of Plant, "I wish that all wealthy men were so democratic, so charitable, so broad gauged and liberal as Mr. Plant."

While Plant made significant contributions in southeastern Connecticut, he lived only a relatively small part of each year in the region. His permanent residence was in Manhattan, and one of his townhouses there is now headquarters for Cartier's, traded to the jeweler in return for a pearl necklace for Maisie. Plant also spent many weeks cruising aboard his yachts and wintering at the Belleview in Clearwater, Florida. His contributions to those communities, as well as to nationwide causes, also were significant. He provided money to establish the hospital that bears his name in Clearwater, for example. His son, Henry, was severely injured in an automobile accident in the Tampa Bay area while the family was staying there, and Plant could

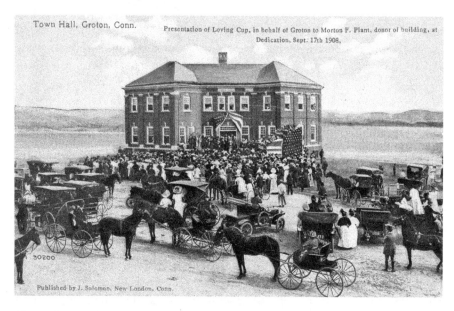

Morton Plant provided the money to build a new town hall in Groton. He was honored at its dedication. *Groton Public Library Local History Collection.*

find no suitable medical treatment in Clearwater. He had doctors and nurses brought in on a special railroad car from Chicago to tend to Henry. Plant also pledged enough money to establish a hospital as long as local residents raised some of the funds. Plant apparently recognized the important role of hospitals in general. In his will, he also left money to New London's Lawrence & Memorial Hospital. Maisie also later bequeathed $1 million to L&M, and her portrait still hangs in the hospital's hall of benefactors.

Besides his interest in tried-and-true transportation systems such as railroads, Plant also demonstrated his vision for transportation improvements of the future. He was excited about the prospects of, and financially bolstered, several cutting-edge transportation technologies. From their earliest appearance on American roads, for example, he loved automobiles, owned several and provided significant financial support to building and improving roads to make driving easier. As an avid yachtsman, Plant was also a major investor in the Cape Cod Canal, which promised to reduce shipping time in the Northeast.

Plant is listed, along with the likes of Cornelius Vanderbilt, as one of thirteen directors of the Interborough Rapid Transit Company, which developed and operated the New York City subway system. The demand

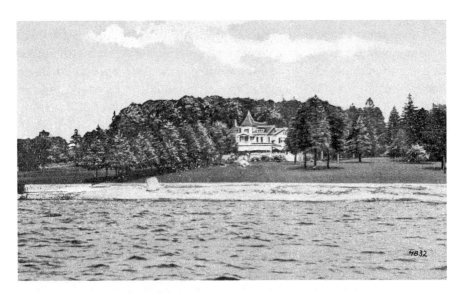

The Watson House at Eastern Point, Groton. Morton Plant bought the house and donated it to the U.S. Navy to use as a hospital during World War I. *Groton Public Library Local History Collection.*

The original Morton F. Plant Hospital in Clearwater, Florida. Plant provided money to establish a hospital after his son was badly injured and there was no proper healthcare facility in the area. *Morton Plant Hospital, Clearwater, Florida.*

for public transportation in the growing city was intense, and while there were horse-drawn streetcars in New York for decades and privately financed elevated trains since the 1880s, the underground system marked a huge step forward in terms of enabling increased mobility for city residents and visitors. The system opened on October 27, 1904, with 9 miles of tunnels and 27 stations. In its first century, the subway system grew to 247 miles of track and 468 stations.

Like many dreamers of his day, Plant also looked to the skies as the possible future of transportation. The *Citizen* newspaper of Honesdale, Pennsylvania, reported on November 24, 1909, under the headline "Wrights in Aero Trust" about the establishment of a new company in New York City. The Wrights' venture was aimed to "control all aviation by heavier than air machines in U.S. and Canada." The brothers formed the company, but it was backed by financiers controlling hundreds of millions of dollars. The newspaper reported that the men behind the flying machine trust included August Belmont, who had ensured the success of the subway system; Cornelius Vanderbilt; Russell A. Alger; and Plant. The article reported that Wilbur Wright would be president of the company and his brother, Orville, vice-president. The company would oversee all the Wrights' patents and prosecute all infringements. The company also planned to construct a large factory near Dayton, Ohio, and the Wrights had plans to manufacture some airplanes that could carry twenty passengers and others to fly the mail to remote regions of the country.

Because of Plant's reputation for supporting causes and new enterprises, he even came to be associated with actions there is no evidence he took. While it was widely reported many years later that Plant helped establish the New London Ship and Engine Company, the predecessor of the modern-day Electric Boat, builders of nuclear submarines, early press accounts about that business and its executives make no mention of Plant. He was, however, a stockholder in the company, as evidenced by his estate listing after his death.

Philanthropy and Tragedy

After the Duke and Duchess of Windsor and the remaining coterie of guests bundled themselves in their furs and satin-lined overcoats and left her Fifth Avenue mansion at 1:30 a.m. on a bitter winter's night in 1954, Mae Cadwell Plant Hayward Rovensky strolled through the silent rooms. In a *Time* magazine article published just after her death at age seventy-eight in 1957, Maisie's personal maid recalled that such wee hour quiet times were Maisie's favorite. It was a time when she leisurely gazed at her porcelains, tapestries and artwork in the lush surroundings. "It's a lovely house for a party," she often remarked.

That particular party would be her last, however. Illness made any subsequent entertaining impossible. But that party was one of countless such society soirees Maisie hosted over a nearly forty-year period from the time she married Morton Plant and through two subsequent marriages. Royalty, celebrities and members of prominent business families, many of whom traced their fortunes to the same era as the Plants, were frequent guests. They arrived glittering in diamonds, draped in pearls and wrapped in satin, mink and silks.

Morton Plant left his third and last wife a multimillionaire when he died during the 1918 influenza epidemic. She fell into their luxury lifestyle during their marriage, decorating their Manhattan townhouse in part with rooms of furnishings bought in Paris, including a dining room designed by Sir Christopher Wren. She dedicated an entire floor of the house for use as a ballroom and had a black onyx bathtub with solid gold claw feet installed in

one bathroom, according to information in a book titled *The Plant Family* by Paula Gemelli. When Maisie visited her friend Grace Vanderbilt, just across the street, Maisie had her chauffeur first drive her around the block so she could make a proper arrival at the Vanderbilt door.

For better or worse, the country's eyes often remained on Maisie and her society friends over the next decades. She was a celebrity until she died.

Plant's private and public legacies were quite divergent. A century after his death, his public legacy focuses on his financial largesse. He made possible the establishment of Connecticut College, paid for building Sacred Heart Church in Groton, built a golf course for his Groton resort that is now owned by the town and continues to function as a public course, operated an East Lyme game preserve that now is Stone's Ranch Military Reservation and funded a variety of public projects that helped raise southeastern Connecticut's public profile. Privately, however, both his biological and adopted sons died quite young, and his widow frequently raised society's eyebrows. Just as there was a protracted battle between Morton and his stepmother over his father's estate after Henry Bradley Plant's death in 1899, there also were struggles between Maisie and Morton's son, Henry, following Morton's death. Morton's estate was reported by *The Day* of New London to be valued at more than $34 million, approximately $537.65 million today. Maisie reportedly inherited some $10 million, plus the Manhattan townhouse. Henry and his family received Branford House, described in numerous press accounts as Connecticut's finest home.

Maisie would never return to her humble, if noble, beginnings as a schoolteacher earning eight dollars a week in the small Connecticut shoreline town of Waterford—the daughter of a Wethersfield, Connecticut family with a long history but without fabulous wealth. From the time she met Plant, who was thirty years her senior, the world's eyes were on her, where they would remain until Maisie died in 1957 at her Newport, Rhode Island mansion, Clarendon Court, a sprawling Palladian-style estate that later gained infamy as the Von Bulow home and the site of the mysterious and still unsolved death of Sunny von Bulow.

Maisie remarried within a year of Morton's death. News of her marriage in 1919 to Colonel William Hayward was well publicized. Hayward was a World War I hero who led a group of black soldiers, dubbed Harlem's Black Tigers, in battles in France such as Belleau Wood. Hayward also served as U.S. attorney for the southern district of New York. He did not ingratiate himself to Newport society, however, after he had four socialite brothers

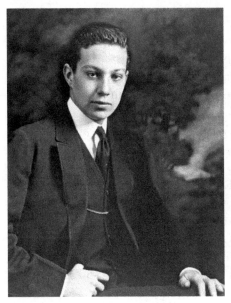 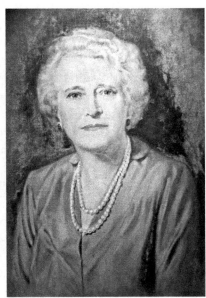

Left: Henry B. Plant II, Morton's only biological son. *Plant Family Collection.*

Right: Mae Rovensky, Morton Plant's third wife, known as Maisie. This portrait hangs in the benefactor's hallway at L&M Hospital, New London, as she bequeathed $1 million to the hospital. *Joseph Geraci photograph.*

there arrested for violating the Volstead Act during Prohibition. Hayward died in Newport in 1944.

A decade later, a *Newport (RI) Daily News* headline screamed on June 22, "Society's Mazie [*sic*], Who Stormed Bailey's Beach, to Marry No. 4." This was the paper's announcement of Maisie's intent to marry Greenwich, Connecticut and New York City banker-industrialist John E. Rovensky. Maisie was married to Rovensky for just three years when she died. Soon after, in the summer of 1957, her former Manhattan townhouse at Fifth Avenue and Eighty-Sixth Street, like many other wealthy society icons' homes in that neighborhood, was demolished to make way for a much taller apartment building.

Morton Plant's daughter-in-law, Amy, loved Branford House and called it her seasonal home for nearly two decades following Morton's death. Her husband's life followed a pattern not unlike his father's and grandfather's. Henry was born on May 18, 1895, in Baltimore, the home city of his mother, Nellie, according to the Plant family genealogy. While Morton was left motherless as a child, Henry was a teenager when Nellie died and his father

married Maisie in 1914. Morton spent much of his childhood separated from his parents. Henry was sent to board at the prominent Pomfret School in rural northeastern Connecticut, a prep school on which his father lavished donations. Like his father, Henry soon found himself with a stepmother who was much closer to his own age than to his father's. Henry later worked for the financial firm of William Salamon and Company and served on the executive staff of two of his father's hotels, the Belleview in Clearwater, Florida, and the Griswold in Groton, Connecticut. He enlisted for service in World War I as an ensign in the U.S. Naval Reserve. But his list of affiliations makes it clear that Henry's greatest loves were similar to his father's: sailing on the ocean or engaged in sport and recreation. He belonged to several yacht, tennis and racquet clubs and the Automobile Club of America. He died in Miami in 1938 at age forty-two on his yacht the *Mascotte*, while his wife and two young daughters were at Branford House. Paula Gemelli, who wrote *The Plant Family* for the Pinellas County Historical Society in 1990–91, wrote that Henry's death was due to toxic encephalitis and polio. She also noted his love of drink.

Henry followed the family tradition of making some sizable bequests, including to New London's L&M Hospital, where he served as a trustee.

Morton's adopted son, Philip Manwaring Plant, Maisie and Seldon Manwaring's biological son, had a reputation as a playboy from a very young age. Dark and classically handsome, Philip made no secret that he enjoyed wild parties, plenty of pretty women, fast cars and carousing. He ran with the New York City Jazz Age theater crowd. The *Philadelphia Inquirer* reported on November 3, 1920, that Plant was the driver of a car carrying five passengers that crashed into a tree in the Bronx, leaving a nineteen-year-old woman, a former member of the Greenwich Village Follies, near death at Fordham Hospital. Philip had hit the tree on the Pelham Parkway.

Philip's first wife was a starlet named Constance Bennett, whom he married in 1925. After his death, she claimed that her son was fathered by Philip, although she never made the claim during his lifetime. She fought against Maisie in court to get a share of the Plant millions for her son. A 1993 column in *The Day* reported that in 1943 Bennett was awarded $150,000, minus $27,000 in legal fees. Despite the lower court's ruling against her, she appealed her case and finally settled it out of court. At that point, her son, Peter Bennett Plant, was a young teenager.

Philip acquired his biological father's Oswegatchie Hotel in 1931 from Edna Manwaring, Seldon's second wife. As a boy, Philip lived with his parents at the property, located in the beautiful but quiet and remote

Philip Plant was known as a playboy but shared his adoptive father's interest in birds. He is shown here with his prize-winning white crested Polish bantam rooster at the 1936 New York Poultry Show. © *Associated Press image, courtesy also Library of Congress.*

Oswegatchie, a section of Waterford located on the Niantic River. He apparently shared some of Morton's interest in birds and animals and brought a herd of cows to the Oswegatchie property, along with many chickens and pheasants. One neighbor complained that Philip had turned the property into a zoo, but Plant's chickens won awards at major poultry shows, just as Morton's had. He also was reported to have one of the world's largest collections of rare birds.

In 1934, newspapers reported that Philip had secretly and quietly married Edna Dunham in Clearwater, Florida. Articles called him a chicken farmer from Waterford. Philip seemed to have inherited his mother's love of a lavish lifestyle. He was reported to have inherited $15 million from his adoptive father and also is reported to have spent his entire inheritance on himself before he was forty.

When he was just forty-two in 1941, Philip died while on an assignment for the Smithsonian Institution, reportedly of a heart attack. Some of the

game he killed while on the safari was donated for display to the Museum of Natural History in New York City.

While Morton Plant left a multimillion-dollar estate, he also died with considerable debt, including numerous personal notes, mortgages on several southeastern Connecticut buildings and companies and largely worthless paper on failing companies and poor investments. The 1915 listing of Plant's estate also details valuable stocks and bonds. The estate included a variety of railroad bonds and bonds from the City of New Orleans and Tampa Union Station. Plant owned $162,000 worth of stocks in the Interborough Consolidated Corporation, which oversaw the New York City subway system, and $33,500 in stock in the New London Ship and Engine Company. He also held stock in several oil companies, Wells Fargo and Western Union and six hundred shares in the Boston, New York and Cape Cod Canal Company. He held a mortgage on New London's Mohican Hotel and owned $32,650 worth of livestock, not to mention $33 million worth of real estate. Morton's estate also listed 150 cases of champagne valued at $7,200, worth nearly $114,000 today. He had one-third ownership of Boston Publishing, which ran two newspapers in that city.

Locally, Morton Plant had helped finance the Norwich Automatic Feeder Company, located on Trumbull Street in New London. Plant owned eighty shares of preferred stock and fifty shares of common stock in the company, which made automatic feeding and drinking devices for poultry. He also made several loans to the Totokett Manufacturing Company in Versailles, Connecticut, to keep the business from failing.

He also had debts that involved two individual women. Anna K. Neyer of Ventnor City, New Jersey, claimed Plant agreed to pay her $1,000 a month for life, plus an annuity of $5,000. Her claim against the estate was settled with $38,500 in cash and the $12,500 payoff of her home mortgage. A second woman, named Jennie M. Lynch, made a similar claim against the estate that was settled for $45,000. The reasons Plant promised the women lifelong payouts were not detailed, but a newspaper report from the *New York Times* on August 16, 1919, said that Ms. Lynch contended the money was promised as "a token of gratitude and in consideration of valuable personal services rendered." The specific nature of those valuable services was left unstated.

Correspondence dated September 18, 1923, lists the total taxable value of Plant's estate at $6.8 million, with estate tax owed of $548,897.88.

Much of his legacy was tied to his beloved Branford House and the farms and gardens surrounding it. Despite being such a focal point for the region,

Branford House also would become a white elephant within a generation, as the country sank into the Great Depression and then plunged into World War II. Even during Plant's lifetime, his farms reportedly ran at a $75,000 annual loss, a cost that quickly became too dear for Plant's heirs to maintain.

A 1939 booklet in the Henry Plant Museum archives details Branford House items listed for sale. The thick booklet compiled by Parke-Bernet Galleries Inc., 30 East Fifty-Seventh Street, New York, lists items ranging from English oak and mahogany furniture to Chinese and Japanese porcelains and bronzes, clocks and hearth garnitures, lamps, Oudenaarde tapestry, broadloom and Oriental rugs, garden furniture and statuary. Detailed lists of specific furnishings were offered room by room, as well as included trees, shrubs, plants and farm equipment from the greenhouses and gardens.

A 1940 appraisal and property report prepared by George B. Horan and Company of New Haven before a sale of the land and outbuildings includes two envelopes full of photographs of empty and neglected buildings that had once housed Plant's gardeners, chauffeur and butler. There also was a boardinghouse for other employees, a boathouse and boat landing, elaborately terraced gardens and greenhouses. There were forty-one acres surrounding Branford House containing Italian sunken gardens, an orangery and squash court, a gate lodge, a laundry house, a poultry house, a garage with space for twelve cars and a machine shop, a work stable, a coach stable, a power house, a carpenter shop, a plumbing shop, a lake and the thirteen-acre Pine Island.

The amenities of the mansion also were detailed: Branford House had three main floors of living space, plus a basement and an attic, eleven bathrooms, doors with bronze and silver hardware, mahogany and oak paneling throughout, satin tapestries on the walls, Terazzo flooring, a pipe organ, an electric call bell and clock system, a soaring reception hall and an ornamental ceiling of exquisite workmanship. Despite the obvious luxury, the appraisers valued the estate at just $100,000 because of the poor economy. The appraisers noted the burdensome annual charge to keep up the estate. The State of Connecticut ended up with much of Plant's land and the Branford House itself. One of his farms was later developed as Trumbull Field, now called Groton–New London Airport. Branford House and its immediate grounds are now part of the University of Connecticut's Avery Point campus.

Morton Plant's gilded age had come to an end.

The Spirit of the Man

This book is meant not as a biography of Morton F. Plant but more a broad portrait of the influence a single man with financial means, community spirit and vision had on a region, both during his lifetime and well into the future. Still, it's impossible to spend so much time researching a person's gifts without also searching to reveal some of the man's spirit and character and to understand the era and personal and environmental forces that shaped him.

Discovering a person's essence nearly a century after his death is a nearly impossible task; further, it's made even more difficult by the fact that both contemporary and later accounts about Plant contain abundant misinformation, contradictions and errors. But by piecing together foundational information with snippets of Plant's personality and character revealed from a variety of sources, a more complete, if still somewhat hazy, picture emerges.

Plant was born in 1852, a fractious, tumultuous time in the United States. His family had a long, stable and distinguished history in Connecticut and lived for generations in the small seaside town of Branford, Morton's birthplace. While the country was being torn apart by the issue of slavery, Plant's family life likely also presented some instability. His mother was sickly and spent her last years in Augusta, Georgia, dying when Morton was still a young child. His father often was absent, tending to his business interests and to Morton's mother. In fact, during the time his father was preoccupied with building his railroad empire, biographers estimate that Henry Bradley Plant saw his son no more than once or twice a year.

Elizabeth Blackstone Plant, Morton's mother. She died of tuberculosis when Morton was eight. *Henry B. Plant Museum, Tampa, Florida.*

Morton spent much of his childhood with grandparents in Branford and New Haven, on the Connecticut shore. Growing up near the sea surely sparked Plant's lifelong interest in boats and the freedom they represented, yet he was likely quite lonely as an only child whose parents were seldom around. His early education was at Russell's Military Academy in New Haven, a place of strict discipline that produced dozens of Civil War Union army commanders. By age sixteen and in the still war-ravaged South, Morton began working for his father's company, the Southern Express. While he held various positions in his father's businesses that carried a fair amount of authority, there is evidence that he did not distinguish himself in his father's eyes.

Morton was already twenty-six years old when he married for the first time, but available information about how or where he met his bride is sparse. The *Expressman's Journal* of 1879, in an article reprinted from the May 10 edition of *New England Homestead* magazine, recounts in great detail the guest list, decorations and wedding attire of those who attended the ceremony uniting Morton in marriage to Ida J. Parsons in Northampton, Massachusetts. Parsons belonged to a distinguished Northampton family and was the daughter of a Civil War hero who was severely injured during the war. She is described as the belle of Northampton in the article, but the marriage appears to have been disastrous. For reasons research was unable to reveal, Ida returned to Northampton alone within a year of her wedding and later remarried and died, apparently in childbirth, in 1882.

The marriage appeared to be virtually invisible and was seldom discussed. No divorce record of the Plant-Parsons marriage was found. Through many years of records, news reports and a wide variety of articles and books, Nellie Capron of Baltimore is called Morton's first wife. Morton and Nellie were married in June 1887, eight years after his failed first marriage. She was about eleven years his junior and the daughter of Francis Brown Capron, who owned several cotton mills in Laurel, Maryland. All accounts portray Nellie as a proper Victorian lady, demure and happy to stay out of the

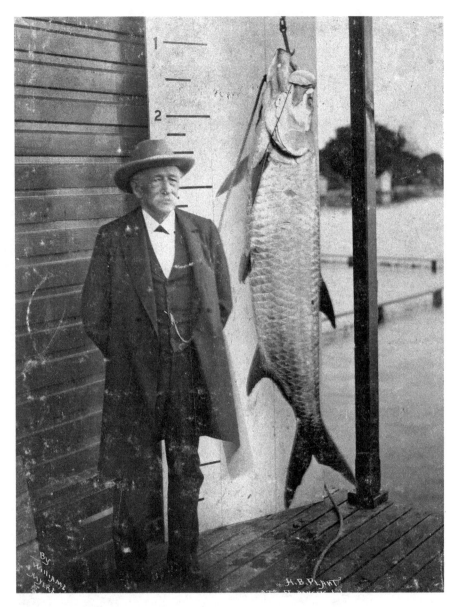

Henry Bradley Plant with a tarpon in Florida. Morton's father was a shrewd businessman who built the family's wealth and helped open the Florida wilderness to tourists and development. *Southwest Florida Historical Society, Fort Myers, Florida.*

public's eye and behind the scenes. She did not share her husband's deep love of the ocean, and although numerous photos were taken of the couple aboard yachts, she was apparently prone to seasickness and often stayed behind while Morton spent weeks or months at sea. Still, Nellie apparently held great influence with Morton. She was an educated woman who studied at the Sorbonne in Paris and was interested in advancing women's education. Indications are she was the driving force behind Morton's involvement in and great financial support of the establishment of Connecticut College. Her design skills came to life in the couple's summer mansion, Branford House, along with two dormitory buildings the couple paid for at the college. But it is a motto that pertains to Morton—"*Jamais Arriere*," or "Never Late"—that is inscribed on a wall at Branford House.

There also are hints that Morton deeply loved Nellie, despite his determination to seldom show emotion. In his journal detailing his nine-month voyage on his yacht *Iolanda*, for example, he noted wistfully how he wished Nellie could have made the journey. He again wrote of his great sadness when a scheduled reunion of the couple in Europe was cut short when Nellie returned to the United States to tend to her ill mother.

Morton and Nellie had one son, born when Morton was already in his forties. As a father, Morton seemed to repeat the pattern established by his

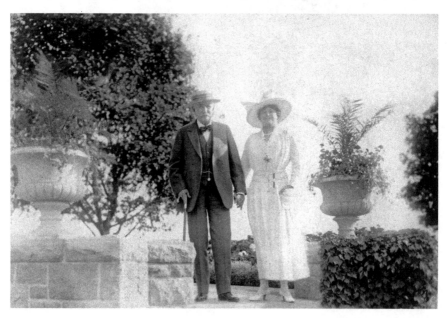

Morton and Nellie in their finest at Branford House. *Plant Family Collection.*

own father. He often was absent, and Henry attended boarding school from an early age, although this was typical for children of families in the Plants' socioeconomic class.

While Morton publicly remained in his father's shadow as long as the elder Henry was alive, given the long lists of boards of directors for a variety of rail, transportation and banking companies on which he served, Morton had to have been taken seriously in the business world of his era. In fact, his obituary in the *New York Times* noted, "The Plant system of railroads bore the marks of his business genius." The obituary also listed him as vice-president and director of the Chicago, Indianapolis & Louisville Railway Company and trustee or director of two Connecticut banks. Still, Morton was either content to allow his father to dominate or was never provided the opportunities to make much of a name for himself while his father was alive. As such, Morton's great community influences began only after his father died in 1899.

Henry Plant's determination to keep his fortune from being squandered by his widow and son left Morton and his stepmother, Margaret, struggling in court to overturn the will's strictures. It was only after they were successful in that pursuit that Morton acted in the manner true to the deeply held beliefs of the extremely wealthy of his era, namely that they had an obligation to share their fortunes with their communities.

Morton also broke from his father in other ways. His political leanings, for example, were more conservative. While Henry was a member of the Union League, clubs focused on loyalty to Abraham Lincoln and the Republican Party, Morton supported the Democrats. The Democrats, especially in Connecticut, were conservative opponents of the progressive movement sweeping the nation at that time. Morton Plant often hosted Democratic gatherings at the Griswold Hotel, and in 1912, he contributed $2,500 to the National Democratic Club. Woodrow Wilson was elected president that year after Teddy Roosevelt ran as a third party progressive candidate, an act that handed his erstwhile friend, Republican William Howard Taft, a huge defeat.

In the final eighteen years of Morton Plant's life, the public's eye was keened on him, his purchases, his contributions and his movements. He was especially hailed in southeastern Connecticut and is remembered a century after his death for supporting local causes, improving local infrastructure, bolstering recreation and investing in local businesses and real estate. He frequently was called pleasant and his sense of humor often noted. He also liked children, and despite what appears to have been an almost unemotional

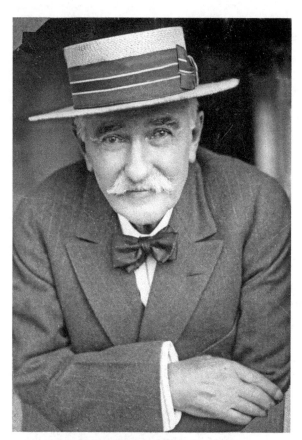

Left: A rare image of Morton Plant smiling slightly and in a casual pose. *Plant Family Collection.*

Below: Plant in his beloved Branford House gardens. *Plant Family Collection.*

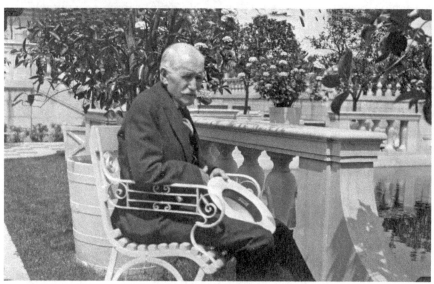

relationship with his own son, Plant was said to frequently stop to talk to and smile at youngsters.

Plant was also a shy man who sought privacy and often shunned public displays of honor. Relatively few photographs of him remain, as he apparently did not like having his picture taken. Even his extensive personal journal from his cruise on the *Iolanda* is largely devoid of personal emotions or insight. Besides his musings over missing Nellie, Morton allows a bit of himself to occasionally slip into the rather dry discourse, however. He noted the shock of watching corpses burned in the Hindu tradition in India, for example. One photograph published in the book shows Morton dancing with a female guest aboard his yacht. Another shows him holding a small monkey.

There is much evidence that he respected those who worked for him, including the fact that he left $1,000 in his will to each servant in his employ for at least ten years. This amount would equal more than $17,000 in 2016 dollars. A tribute published in the *Boston Herald* just after his death also demonstrates a bit of Plant's essence: "His investment here went back to the unprofitable days when it took good courage as a capitalist and faith that the right kind of a newspaper would win out to keep up the stream of revenue necessary for its maintenance." The *Herald* also noted Plant had lived in Boston for a period "as a youth" and that Plant's investments were made with the community's benefit and patriotism in mind.

After Nellie died of typhoid in August 1913, Morton remained a widower for less than a year, marrying his third wife in June 1914. It was the marriage to his last wife, known as Maisie, that made the biggest public splash. She was half his age and seemed to adore the public spotlight and all the trappings of high society. He clearly was smitten with what today would be considered his trophy wife.

Morton also suffered from illnesses and injuries that affected his life. He appears quite frail in photographs from his later years. He used a cane to walk, although even then it was noted on some occasions he walked only with difficulty. Ultimately, he succumbed in the 1918 influenza epidemic, perhaps because his health already was compromised.

Despite his public legacy, Morton Plant the person remains somewhat of an enigma, almost a two-dimensional person whose upstanding character is most often noted by those who sought hefty donations from him. His lifelong quest to remain private despite constant pressure for public access is illustrated in a story recounted by Gertrude E. Noyes in her 1982 book *A History of Connecticut College.*

A *New London Telegraph* reporter showed up at Branford House to ask Plant about the $1 million donation he made that turned the dream of establishing a women's college in New London into reality. The reporter asked to conduct a lengthy interview with Plant. Plant instead stated the facts quite briefly and "then closed the interview by turning to his pet parrot, asking, 'Polly, want a glass of port?'"

Plant then shut the door, closing the reporter, and the world, out.

SELECTED BIBLIOGRAPHY

Books

Cavin, Ruth. *Trolleys: Riding and Remembering the Electric Interurban Railways.* New York: Hawthorn Books, 1976.

Cudahy, Brian J. *A Century of Subways.* New York: Fordham University Press, 2003.

————. *The New York Subway, Its Construction and Equipment.* New York: Fordham University Press, 2004.

Gemelli, Paula. *The Plant Family.* N.p.: Pinellas County Historical Society, 1990–91.

Kimball, Carol W. *Remembering Groton: Tales from East of the Thames.* Charleston, SC: The History Press, 2008.

Kimball, Carol W., James L. Streeter and Marilyn J. Comrie. *Images of America: Groton.* Mount Pleasant, SC: Arcadia Publishing, 2004.

————. *Images of America: Groton Revisited.* Mount Pleasant, SC: Arcadia Publishing, 2007.

Massie, Robert K. *Dreadnought: Britain, Germany, and the Coming of the Great War.* New York: Ballantine, 2012.

Noyes, Gertrude E. *A History of Connecticut College.* New London, CT: Connecticut College, 1982.

Plant, Morton F. *Cruise of the Iolanda.* New York: Knickerbocker Press, G.P. Putnam's Sons, 1911.

Reynolds, Kelly. *Henry Plant: Pioneer Empire Builder.* Cocoa: Florida Historical Society Press, 2003, 2010.

Rousmaniere, John. *The New York Yacht Club: A History, 1844–2008*. New York: Seapoint Books, 2008.

Smyth, G. Hutchinson. *The Life of Henry Bradley Plant*. New York: G.P. Putnam's and Sons, 1898.

Stemmons, Walter. *Connecticut Agricultural College: A History*. New Haven, CT: Tuttle, Morehouse & Taylor Company, 1931.

Turner, Gregg M., and Melancthon W. Jacobus. *Connecticut Railroads: An Illustrated History*. Hartford: Connecticut Historical Society, 1989.

Walker, Alan J. *Images of Rail: New London County Trolleys*. Mount Pleasant, SC: Arcadia Publishing, 2004.

Booklets

Brown, Canter, Jr. *Henry Bradley Plant, the Nineteenth Century "King of Florida."* Tampa, FL: Henry B. Plant Museum, 1999.

———. *A Late Victorian Romp: The World as Seen from the Tampa Bay Hotel's Veranda, 1891–1901*. Tampa, FL: Henry B. Plant Museum, 1999.

Giant Steps: The History of Morton F. Plant Hospital. Article on Morton Freeman Plant, n.d., 8.

Gonzalez, Robin Robson. *If Our Hotel Could Talk*. Tampa, FL: Henry B. Plant Museum, 2005.

Lenfestey, Hatty. *An Elegant Frontier: Florida's Plant System Hotels*. Tampa, FL: Henry B. Plant Museum, 1999.

Lenfestey, Hatty, ed. *Moments in Time*. Tampa, FL: Henry B. Plant Museum, n.d.

Lenfestey, Tom. *Bells and Whistles: The Plant Transportation System*. Tampa, FL: Henry B. Plant Museum, 1999.

Sacred Heart Parish: 75th Anniversary, 1915–1990. N.p.: self-published by the parish.

Interviews

Cataldi, Tom. Interview by author, July 2015.

Streeter, James, Groton Town Historian. Interview by author, December 2015.

Journal Articles

Clampett, Randal L. "On the Trail of the Shoreline Trolleys." *Heading Out*, October 1985.

Electric Railway Journal. "Shoreline Ordered to Install Lower Steps" (February 7, 1914): 335.

Phinizy, Catherine. "The Bighearted Millionaire." *Connecticut College Magazine* (Spring 2000): 22.

Schreiber, Mike. "The Shoreline Electric Railway." *Shoreliner* magazine (n.d.).

Sperry, A. William. "The Shoreline Electric Railway." *Electric Railway Journal* (n.d.): 76–94.

Letters, Papers and Other Miscellaneous

Branford House files, miscellaneous brochures, booklets, clippings, appraisal report, photographs. Dodd Center special collections, University of Connecticut, Storrs, Connecticut.

Branford House nomination to National Register of Historic Places, December 12, 1983.

Branford House report, Sydney Wood Hall, 1983.

Brochures for the Griswold Hotel.

Captain Charles A.K. Bertun Collection. Mystic Seaport archives.

Cartier's archives, photos, blueprints of Plant's home, now Cartier's flagship store.

Cedar Grove Cemetery, visit.

Delmore. James L. "A Caddie's First Day." Undated.

Dutka, Elizabeth S. "The People of Avery Point—Memories as History." May 8, 1989.

Elizabeth Wright archives, including typed biographical information about Morton Plant, Connecticut College archives.

Estate listing of Morton F. Plant. Colin S. Buell Papers. New London County Historical Society archives.

From Posh Country Club to Municipal Golf Course. "Featured Course— Shennecossett." Donald Ross Society report.

Groton land records.

Groton probate records.

Henry B. Plant Museum archives, letters, photographs, internal hotel brochures and correspondence from Plant regarding establishing his New London baseball team.

James Streeter video. Morton F. Plant role play.

New London land records.

New York Yacht Club Catalogue of Models. *Elena, Iolanda, Ingomar* and *Shimna.*

Plant Family Genealogy.

Tampa Bay Hotel, Florida's First Magic Kingdom. Henry B. Plant Museum video.

Voyer, R.A. "Featured Course—Shenecossett [*sic*] Golf Club, Groton, Connecticut."

William Butler Duncan Papers, 1902–1932. Mystic Seaport archives.

Young Collection. Connecticut trolley history. Dodd Center special collections, University of Connecticut, Storrs, Connecticut.

Newspaper Articles

Andersonville (SC) Daily Intelligencer. "Three Hundred Million in Suit for Restitution." July 18, 1914.

Braccidiferro, Gail. "Branford House—Legacy of the Past." *The Day,* July 12, 1980.

———. "Planes Replaced Herds of Cattle in Seaside Pasture." *The Day,* September 27, 1982.

Branford (CT) Review. "Too Many Wrecks Spelled Doom for the Shoreline Trolley." August 1, 1963.

The Day. "Estate Value at the Time of Death." August 27, 1921.

———. "Italian Laborers Arrive." March 17, 1903.

———. "Magnificent Gift." June 5, 1911.

———. "Morton F. Plant Started Career to Wealth at 16." February 17, 1965.

———. "Mrs. Amy Plant Paterson; Family Built Branford House." Obituary, November 4, 1981.

———. "Plant Gives $1 Million to College Operations." June 3, 1911.

———. "Skillfully Applied Wealth Has Created Grand Palace by the Sea." April 6, 1905.

———. "Town Hall Dedication." September 18, 1908.

———. "Yacht Iolanda Back in Harbor." July 5, 1910, 6.

Flinn, Jacky. "Album Chronicling Branford House Construction Found." *The Day,* February 9, 1982, 13.

———. "Plant Family Supports Efforts to Save Mansion." *The Day*, January 5, 1982, 9.

Foley, John. "When Movie Star Played Out Tabloid Script in New London Court." *The Day*, November 29, 1993.

Fort Worth Star-Telegram. "Plant Gives Yale Crew Land and House at Gales Ferry." January 1, 1906.

Gloversville (NY) Morning Herald. "Score Dead and 50 Hurt in Worst Trolley Crash in History of New England." August 14, 1917, 1.

Harrisburg (PA) Telegraph. "Boston Herald Sold for $1.8 Million." September 15, 1915, 6.

Hartford Courant. "Another Tragedy Narrowly Averted on the Shore Line." August 20. 1917, 5.

———. "Boston Herald's Tribute to M.F. Plant." November 6, 1918, 6.

———. "Bridgeport Wins Game by Forfeit." June 15, 1918, 12.

———. "Bungalow for Plant." February 18, 1908, 11.

———. "The Connecticut College for Women at New London." August 1, 1915, X3.

———. "Divorcee Will Not Wed Morton F. Plant." April 22, 1914, 6.

———. "Eastern League Club Owners Show Confidence in Baseball." May 19, 1918, 2.

———. "Eastern Point Farmers Fight Army Worm." July 24, 1914, 15.

———. "18 Killed, 14 Injured in Crash on Shoreline Electric." August 14, 1917, 1.

———. "Game Preserve Loaned to State." February 18, 1914, 4.

———. "Hotel Griswold Opens Next Week." June 17, 1910, 15.

———. "Many Autoists Go to Eastern Point." July 13, 1910, 6.

———. "M.F. Plant's Yacht, Vanadis, Mistaken for German Ship." December 2, 1915, 1.

———. "The Model Stock Farms of Morton F. Plant." October 11, 1914, X3.

———. "Morton F. Plant Heads Trustees." May 2, 1911, 16.

———. "The Morton F. Plant State Game Preserve at East Lyme." September 20, 1914, X7.

———. "Morton F. Plant to Buy Street Railway." May 24, 1912, 15.

———. "Morton F. Plant to Wed Mrs. Manwaring." May 26, 1914, 6.

———. "Morton Plant Buys Mansion at Eastern Point." July 7, 1918.

———. "Mrs. Manwaring Wed to Commodore Plant." June 19, 1914, 6.

———. "Mrs. Plant Hostess at Branford House." July 27, 1911, 14.

———. "New Contest to Begin at Storrs." November 2, 1914, 20.

———. "New London Man Buys Plant Farm." July 16, 1920, 18.

———. "No String on Mrs. Plant's Gift." July 23, 1916, 18.

———. "O'Neil Penalizes Bridgeport Club." June 19, 1918.

———. "Peace Conferees at Eastern Point for Joint Session." September 6, 1916, 1.

———. "Plant Leaves $250,000 for Women's College." November 15, 1918, 8.

———. "Sea Plane Sport at Eastern Point." July 30, 1916, 1914, 1.

———. "State Opposes $900,000 Claim by Executors of Morton F. Plant Estate." June 28, 1921, 1.

———. "Thames College Gets Million Dollar Gift." June 5, 1911, 6.

———. "Trolley Crew Is in Jail without Bail." August 15, 1917, 1.

———. "Upkeep of Plant Mansion in Court." April 23, 1920, 10.

Honesdale (PA) Citizen. "Wrights in Aero Trust." November 24, 1909, 1.

Kimball, Carol. "Groton's Most Prominent Citizen." *Groton Standard*, June 24, 1982.

———. "Town Hall 100th Anniversary." *Groton Standard*, September 17, 2008.

Macon (GA) Daily Telegraph. "Commodore Morton Plant Narrowly Escaped Death." January 20, 1907.

New London Telegraph. "Ball Tossers' Costumes." February 8, 1913.

Newport (RI) Daily News. "Society's Mazie, Who Stormed Bailey's Beach, to Marry No. 4." June 22, 1954.

(New York) Sun. "Morton F. Plant to Marry Mrs. Selden B. Manwaring." May 26, 1914, 6.

———. "Mrs. Morton F. Plant Dead." August 8, 1913, 7.

———. "Yachtsmen of the World." July 5, 1914, 3.

New York Times. "Capitalist Weds Divorcee at Branford House, His Summer Home in Groton." June 18, 1914.

———. "Contest Over Plant Will." November 15, 1899.

———. "The Griswold Scene of Many Brilliant Parties This Week." July 4, 1909.

———. "H.B. Plant's Estate." May 4, 1902.

———. "Henry B. Plant Dead." June 24, 1899.

———. "Henry B. Plant, 42, Dies on His Yacht." February 26, 1938, 21.

———. "M.F. Plant in Baseball." February 8, 1913, 14.

———. "Model Farm One of Connecticut's Proudest Boasts." June 15, 1913.

———. "Morton F. Plant Dies of Pneumonia." November 15, 1918.

———. "On the Social Treadmill." July 31, 1904.

———. "Plant Contributed $2,500 to National Democratic Fund." July 17, 1912.

———. "Plant Will Contest Will Worth $17 Million." January 16, 1901.

———. "Society Day at 9th Annual Auto Show." January 20, 1909.

———. "30 Hurt in Trolley Wreck at Guilford." May 5, 1912.

Norwich Bulletin. "Elks Day at Plant Field." August 26, 1916.

———. "Morton Plant Pays Record Price for Cattle (to Paint Newent Church)." May 12, 1911.

———. "New Highway from Poquonnoc to Mystic." April 5, 1912, 8.

Philadelphia Inquirer. "Morton Plant Better." May 3, 1903.

St. Albans Daily Messenger. "Stonemasons, Bricklayers and Plasterers Out at Groton." December 31, 1903.

St. Albans Messenger. "A Big Strike Threatened." December 31, 1903.

Streeter, Jim. "Didja Know?" *Groton Times*, June 3, 2005.

———. "The Three Farms of Morton F. Plant." "History Revisited" column. *Groton Times*, September 25, 2008, 12.

Tidings. "Morton F. Plant, His Lavish Spending Made Wonderful Newspaper Copy" (July 1987).

TIME. "Art: End of an Avenue" (January 21, 1957).

Times. "Woman Seeking Plant's Money." August 16, 1919, 8. Available at James Blackstone Memorial Library archives, Branford, Connecticut.

Trinity Tripod. "Robert Gallaudet Erwin, Ex-President of Atlantic Coast Line Dies Suddenly." January 16, 1906, 1.

INDEX

ABOUT THE AUTHOR

Gail Braccidiferro MacDonald is an associate professor in residence in the journalism department at the University of Connecticut–Storrs. She is a former reporter for *The Day* of New London, Connecticut, and a veteran journalist whose work has been published in numerous newspapers and magazines, including the *New York Times*, the *Hartford Courant*, the *Providence Journal*, the *Los Angeles Times*, *Rhode Island Monthly*, *American Artist* and *Vermont Life*. MacDonald, who has won numerous awards and recognitions for her journalism, has a deep appreciation and love of history and is especially attuned to the way the events, people and trends from the past continue to shape contemporary society. She has one adult daughter and lives in southeastern Connecticut with her husband.

Visit us at
www.historypress.net

CPSIA information can be obtained
at www.ICGtesting.com
Printed in the USA
LVHW061128220320
650823LV00011B/190

CAB —
. just ok .